RotoVision

D0691381

For Kim and Ursula.
For our mentors.
JB and MW

A RotoVision Book

Published and distributed
by RotoVision SA

Rue Du Bugnon 7
CH-1299 Crans-Près-Céligny
Switzerland

RotoVision SA
Sales and Production Office
Sheridan House
112/116A Western Road
Hove, East Sussex BN3 1DD
United Kingdom

tel +44 (0) 1273 72 72 68
fax +44 (0) 1273 72 72 69

e-mail sales@rotovision.com
net www.rotovision.com

Production and Separations in Singapore by
ProVision Pte. Ltd.
tel +65 334 7720
fax +65 334 7721

Book, type
sequences,
and interactive
design by:

Text: © 2000 Jeff Bellantoni and Matt Woolman

Inquiries: studio@ization.com

Typefaces: Myriad, Garamond, and Bodoni
families

Looping Birds and *Face on a Mountain* from the
album *Lost in Density* ©1995 Ben Woolman and
Floating Feather Music

Matt Woolman

Jeff Bellantoni

MOVING
type

Designing for
Time and Space

Book and CD-ROM

Moving Type is both a book and a CD-ROM. They rely on each other, and should be viewed simultaneously when possible. The book contains all of the textual information and still images from the typographic animations, design student projects, and professional examples. The CD-ROM images are numbered according to sequence number and page number.

sequence number **022** | **036** page number

The two sequences for the fundamental of distortion, shown here, are representative of how examples are presented in the book with the appropriate sequence/page number. To access a sequence on the CD-ROM, go to the appropriate QuickTime™ clip that has the same number combination as the example in the book and open the sequence through MoviePlayer or QuickTime™ player.

Technical requirements: Macintosh operating systems require the QuickTime™ extension 3.x or higher, and MoviePlayer™ or QuickTime™ player. Windows 00/98/95/NT operating systems require the QuickTime™ extension 4.x and QuickTime™ player. QuickTime™ player is a free download from www.apple.com/quicktime.

All of the sequences presented have been provided as a courtesy by the designers, educators, companies, and universities responsible for their production. Please do not copy these sequences from the CD-ROM onto a computer storage system except for the sole purpose of viewing. Please respect the copyright owners of the sequences and the copyright of the CD-ROM on which they reside.

Many of the student sequences were created in the spirit of educational experimentation, some of them may contain audio clips which have a commercial copyright. Every effort has been made to credit the original sources where possible.

021 | **036** Distortion: crop

022 | **036** Distortion: fracture

MoviePlayer™ control panel

QuickTime™ Player control panel

Table of Contents

Moving Type is about type, space, and time. Our intention is to introduce professional and student typographers, graphic designers, animators, Internet, film and television broadcast designers—anyone who creates messages that have a life on a screen—with a fundamental set of principles upon which to build, a point of departure from which to diverge. This book speaks to those aspects of typography that can only exist on a monitor or projection screen.

Typography is the art and technique of creating and composing type in order to convey a message. The term 'type' includes the design and function of alphabetic and analphabetic symbols to represent language. Typography has evolved within the tangibility of printing with interchangeable characters. Printed type involves an active reader, with an active eye navigating around the page. The characters are static, the reader's eyes move.

By contrast, spatio-temporal typography is kinetic—the characters move, the reader's eyes follow. It is ephemeral. The experience is fleeting. Nothing is left when it is over, except an impression. These events are, for the most part, intangible, as they exist in the *virtual* space of the computer monitor, video screen, or cinematic projection. This begs the question: do we classify the audience of moving type as viewers, readers, or visitors? Do typographic animators design for each disposition, or is it even necessary to distinguish between the three?

The discipline of typography has evolved from movable type to moving type, from designing physical objects to designing events and digital environments. Because moving type is dependent on time, it is important for designers to create a resonating impression and emotional attachment to their message. The motion itself is mesmerizing. Caution must be paid to the transfixing quality of moving typography, for fear that entertainment will supersede communication. Never before have designers had such access to, and such a variety of, tools for literally bringing type to life and flirting with legibility. These same tools also provide an opportunity to enhance expressiveness and support the meaning within a body of text—to engage the public emotionally, intellectually, and physically. Setting—or releasing?—type into motion implies a seductive lack of restraint, however, and the danger of the designer's—author's?—voice overshadowing and disrupting the story or message through over-stylizing is tremendous.

But with today's expectations of visual capabilities, the emotional responses that movement and visual effects can conjure up are often desired and even expected. Technology makes it easy to create 'eye candy' and complexity in forms—the addition of animation makes it even easier. On television, sports graphics, flying logos with whooshing sounds, and news networks with vertical and horizontal information graphics visually taunting the anchor person also overwhelm the screen and the audience.

So what does this all mean for the established, over 500-year-old, fundamentals of typography, which have been expanded and refined by some of the most respected typographers in our history? Do we discard these canons and eject our 2,000-year-old letterforms into space like acrobats on a trapeze? Certainly not. To make an impression and emotional attachment without losing sight of intent, the designer must strive to balance the semantic (meaning), syntactic (form), and pragmatic (function) concerns of the situation at hand. If form overwhelms the message, all is lost except temporary stimulation for the eyes.

The sound fundamentals of typography are even more important as visualization technologies enter the 21st century. These fundamentals do not, however, simply transfer themselves to the realm of time and space. The first question every typographer and designer must ask is: does the type need to move? Will movement benefit the viewer, or reader, at all? Is the intent to entertain, or communicate, or both?

Designers should not allow the 'moving' in moving type to overshadow the message. It has always been, and continues to be, important that the message and the idea behind a piece of visual communication balances with the form that it takes. Designing type well is based on a set of fundamentals that, once understood, balance the expressive and functional aspects of visual communication. The emotional connection between the designer and the formal aspects of the project is highly desirable—designers do not like to think of themselves as merely the *hands* that work the *tools*. They want to inject creativity, theories, experiments, and intelligence into the information and stories they are communicating. Therefore, moving type requires a number of principles and fundamentals of its own to govern the discipline.

Typography, unlike the spoken word, dance, music, or film, is not inherently kinetic or dynamic. The letters that make up most alphabets in most languages were designed to be read flat, frontal, and upright. But letters can be animated, and in the process of becoming dynamic typography can take on the intonations and the *voice* of the spoken word, the emotional characteristics of dance or music, or the narrative qualities of film. These are all exciting and promising ways of exploiting typographic messages in time-based media and presenting new ways of reading, viewing, and even visiting.

This is what we have attempted to do with *Moving Type*. We offer the beginnings of a discourse on the fundamentals of spatio-temporal typographics or, more simply put, typographic animation. We have developed these fundamentals through a process which combines the established fundamentals of typographic design with principles of time-based media such as film and animation.

This book will also function as a point of departure for further investigation. For example, the study of film semiotics provides the designer with an understanding of how a particular image on the screen communicates, evokes, or informs—through the composition of a particular scene, the camera angle, the colors, and so on. An understanding of the emotional aspects of sound would provide the designer with the ability to look with a more critical eye at the audio component of a particular project, influencing the typographic decisions that are made.

Moving Type is about typography that moves, transforms, mutates, duplicates, blurs, interacts—but it is intentionally not specific to film title, television broadcast, or Internet design, as each of these mediums contains its own technological limitations and nuances that can only be experienced first-hand. This book will attempt, however, to provide an introduction to, and understanding of, some of the technology involved in designing for time and space, provided in four mini-sections, devoted to color, legibility, animation, and pre-production planning.

Moving Type presents several university design education programs that are implementing spatio-temporal typographics into their curriculum, and investigates student projects that take various approaches to teaching, from basic visual exercises to theoretical experiments. Finally, this book presents five professional profiles practicing in film and television titles, television program and channel identities, typographic editorials and performances, and human-computer interfaces.

Graphic designers and typographers have a tremendous amount to contribute to film, television, and digital media. The cultural impact these media have, and will continue to have, on society is great. But designers must contribute more than mere aesthetics. As information grows more complex, more specialists are needed to organize it into forms that audiences can use. Technologies play a strong role in this process. Often, it is the technology that allows the information to spawn at a mind-numbing rate (read here: Internet). This rapid growth is even placing the simple letterforms—the symbols of language and communication—in formal and functional jeopardy. Will there be a need for such objects in our future? Will the *A* as we know it, or the *B*, or *Z* need a structural overhaul in order to take flight or enter three-dimensional space? We hope that *Moving Type* will become an agent for addressing these and other questions that will undoubtedly arise as long as communication technologies evolve and information continues to propagate.

anatomy
staff
x-height
weight
width
posture
point size
spacing

Typography

Typography is the art and technique of creating and composing type in order to convey a message. The term 'type' includes the design and function of alphabetic and analphabetic symbols to represent language. The fundamental element of a letterform is the stroke. Each modern, western letterform has evolved as a simple symbol, whose visual characteristics distinguish it from the others. For example, the capital letter A is recognized as having two vertical strokes that converge at an angle to form a triangle that is intersected by a horizontal stroke. Many letterforms share the same parts. This helps in understanding the alphabet as a system of symbols.

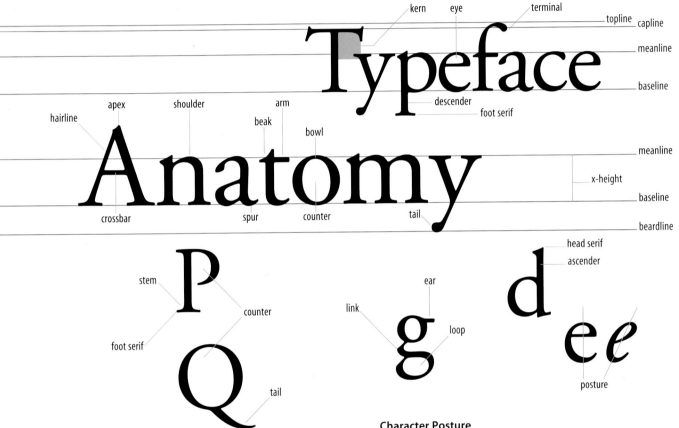

WE**IGHT**

Character Weight

The blackness, or heaviness, of a character is referred to as its weight. The weight of a character is determined by the relationship of the thickness of its stroke to its overall height. Traditionally, a typeface is designed with at least two weights: regular and bold.

WI**DTH**

Character Width

The width of a character is determined by the interval of space between its vertical strokes and counters. Common terms describing widths include condensed, regular, and extended. There is no standardization of weights and widths in typography. They are relative measures that depend on the design of a specific typeface.

Character Posture

The standard, upright posture of a character is known as Roman because it emerged from the alphabet refined by the Romans. The Roman-refined alphabet consisted of vertically upright and stiff letters until the fifteenth century. In 1498, a scholar and printer named Aldus Manutius opened a press in Venice to print Greek and Latin texts in several languages, including Italian, French, and Latin, but felt too limited by the vertically-oriented letters of the Roman alphabet.

In 1499, Aldus commissioned a typefounder named Francesco Griffo to create a typeface that resembled cursive handwriting, in order to print letters closer together and to fit more words on a page. Griffo produced what became the first italic letters. Characters that slant to the right and are different in structure from Roman forms are known as italic. The original italic forms were developed to be distinct from, yet complementary to, their Roman counterparts in the same typeface.

Characters that slant to the right but resemble Roman characters in structure are known as oblique, or sloped Roman.

Roman **Roman**

Italic *Oblique*

a a a a a a a a a a a a a

6 8 10 12 14 18 24 36 42 60 72

144 pts

72 pts

0 pts

Character Size

The size of a character was originally determined by the size of the three-dimensional block on which the face of type was cast, rather than the character itself. The measure of digital type is still based on the characteristics of cast-metal sorts. The point size of a digital typeface is determined by the highest ascender and lowest descender of the typeface. Traditionally, with printed type, sizes below 12 points are considered text type. Type that is set above 12 points is considered display type, and is used for headlines, signage, and other contexts where large type is necessary. These rules of thumb must be altered on a case-by-case basis when considering type in motion, especially type that is displayed on a computer screen or video monitor.

Character Spacing

Each letter of the modern western alphabet has a width determined by its inherent structure. Because of this, letters are assembled into words with what is known as differential spacing. This is the spacing of each letter according to its individual width (Fig. 01).

s p a c i n g

spacing

Fig. 01

Character Tracking

Tracking applies to the uniform space adjustment of the letters in an entire word, sentence, paragraph, or larger text block. Sans-serif and condensed lowercase characters are traditionally set with normal-to tight tracking. Serifed lowercase characters are traditionally set with normal-to-loose tracking. Type set in all capitals should have normal-to-loose tracking. Tracking should never be confused with kerning (Fig. 02).

Tracking

Tracking

Tracking

Fig. 02

Character Kerning

Kerning applies to the space relationship between two specific characters. In most cases, when two letters are placed next to one another, the set widths of the respective faces allow the characters to fit close enough to be considered part of a word. There are some instances in which the space of one character must be violated by its neighbor in order to achieve consistent spacing in a single word. In cast-metal typesetting, notches were cut out of the metal blocks to allow characters to fit closely. The space created to allow two characters to fit close together is known as the kern. Certain letters create awkward spacing when paired with one another. For example, letters with long horizontal strokes such as the T, and dominant, angled strokes such as A, V, W, Y, contain more space in their zones than other letters. The numeral 1 is also a difficult letter to space, due to its narrow width (Fig. 03).

Kerning

Fig. 03

Interline Spacing

Interline spacing is commonly referred to as leading, a term that originated with cast-metal typesetting. In this process, interline spacing was adjusted by inserting strips of lead between lines of type. In digital typesetting, the term leading is used to describe the vertical distance between sequential baselines of type. Here, the leading value equals the sum of the point size of the type used and the amount of space added between baselines (Fig. 04).

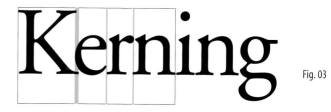

In metal typesetting, interline spacing was adjusted by inserting strips of lead between lines of type. In digital typesetting, the term "leading" is used to describe the vertical distance between sequential baselines of type.

In metal typesetting, interline spacing was adjusted by inserting strips of lead between lines of type. In digital typesetting, the term "leading" is used to describe the vertical distance between sequential baselines of type.

In metal typesetting, interline spacing was adjusted by inserting strips of lead between lines of type. In digital typesetting, the term "leading" is used to describe the vertical distance between sequential baselines of type.

Fig. 04

Legibility

Issues of technology are extremely important to understand in moving type. Every issue of technology affects the overall legibility of a sequence. Legibility is more than just the ability to be read; it includes the appropriateness and effectiveness of the decisions made by the designer in relation to the technical aspects of medium and context.

Medium and Context

Medium is the means by which something is communicated, its physical makeup—paint on a canvas, print on a page, videotape, film, and binary code on a disk, for example. media can be further delineated as either analog or digital formats.

The context in which a particular medium exists further defines it—the painting hangs in an exhibition or gallery, the printed page exists in the book, the video signal is broadcast over television, the film is projected in the theater, the binary code is the makeup of a website which exists on the Internet. Then there is the process involved, the act that occurs. You either animate something, film it, paint it, or typeset it.

However, a problem occurs in attempting to differentiate the various media in their various contexts, due to the digitization of most of them. Digital video is binary code recorded on a magnetic videotape. The image seen on the video screen is binary code transformed into a video signal. *Digital* video/film/etc. is an oxymoron. This same digital video signal can be seen on the website itself, no longer needing videotape at all. Film is experiencing the same gender confusion. The addition of the word 'digital' to these traditionally analog terms adds to the confusion: digital film, digital video, digital animation, digital imaging, etc.

Context is important because, for example, designing a sequence for the cinema is quite different than designing one for a website—the experience of the audience in the cinema is not the same as that of someone sitting at a computer in an office or at home. Film relies on the phenomenon of suspension of disbelief, the psychological element which gives a film its reality. When people sit in a theater and view a film, they suspend reality and accept what is occurring before them as real experience occurring at that moment that they are participating in, sharing the same spatial and temporal continuums as the image on the screen. The dark atmosphere of the theater and the scale of the screen, which is larger than life, are elements which allow for suspension of disbelief to occur. The environment and physical limitations of the computer, as well as the existence of an interface, and interaction and choices by the audience, eliminates suspension of disbelief.

When designing for time and space, the question of medium (in what medium will the sequence be seen?) and context (where will the sequence be seen?) must be answered before any other decision can be made.

Analog versus Digital

Analog media consists of signals or information that is represented by a continuously variable quantity, capable of smooth fluctuations. Electric current, waves of water, light, sound, and most everything in nature are analog.

Digital media consists of signals or information represented by digits or numbers, based on the binary numbering system that makes up computer codes. The value differences exist in discreet steps, as opposed to smooth fluctuations. Most modern electronics are digital (Fig. 01).

Digital media is superior to analog media due to several factors. Analog media degrades when copied, a process known as generation loss. Digital media is not subject to generation loss, and can be manipulated a great deal without affecting its quality. Digital media is not affected by the properties of other media, for example a digital video signal can be recorded on an analog magnetic tape.

Digitization

When an analog signal is digitized it goes through a process called compression, or rendering. How often the analog signal is digitized is called the sampling rate, the main determinant of resolution. The higher the sampling rate, the higher the resolution. Digital files can also be compressed. There are numerous compression choices depending on the intention of your digital file. For instance, will it be shown on the Internet or CD-ROM? Will it be transferred to analog videotape or film?

The process of converting the digital signal back to an analog signal is called decompression. There are various codecs, hardware- and software-based compression and decompression algorithms, that can accomplish this. The word *codec* is short for compressor/decompressor.

Codecs minimize the file size of the sequence, and ensure smooth playback and cross-platform abilities of video and audio. Simply put, codecs compress the data using temporal and/or spatial compression techniques.

Spatial compression removes redundant data within any given image by generalizing the coordinates and color of an area within the frame, ignoring the little details. Temporal compression looks at consecutive frames and only retains the elements of each image that change between each frame. Certain frames remain as an entire image—these are called keyframes. The remaining frames, which only contain the information that is different between keyframes, are called delta frames.

Fig. 01

Analog waveform

Digitally sampled waveform, 1 x sampling rate, 1 x resolution

Digitally sampled waveform, 2 x sampling rate, 2 x resolution

Pixels and Bitmaps

In order to render a letterform for screen display, the character must be rasterized, or converted into tiny dots known as pixels, short for *picture elements*. This process takes place on a bitmap matrix that contains 72 pixels per inch, which is the average *device resolution* of a computer monitor. The dot, also known as the pixel, is the smallest visible element displayed on the computer monitor (Fig. 02).

The *display resolution* refers to the number of pixels in a horizontal scanline times the number of scanlines. A display that is 832 x 624 has 832 pixels across each of the 624 lines for a total of 519,168 pixels.

The process known as *hinting* allows the computer to render a specific typeface accurately at different sizes when displayed at low resolutions. Pixels, due to their modularity, can form most anything, although they are governed by a grid structure. Larger type contains more pixels forming the letterform, therefore the letterform will appear smoother (Fig. 03).

The computer uses an outline construction to precisely match the original type design. This allows the printer to render a letter with smooth curves and angles, instead of the jagged, or aliased, construction of pixels (Fig. 04).

When the computer cannot render a character properly on the screen, the condition known as *jaggies* occurs, rendering the smooth curve or angle of a character into a stair-stepped pattern (Fig. 05).

When a typeface is used strictly for screen display, the computer can reduce the jagged effect of the bitmapped letterform by averaging the color density of pixels at its edges with the background. This process is known as anti-aliasing, and gives the hard, stair-step edge a soft appearance that simulates a smooth curve (Fig. 06).

Fig. 02

Fig. 03

72pt 36pt 24pt 18pt 12pt

Fig. 04

Fig. 05

Fig. 06

Reading on the Screen

There are a number of factors that affect our ability to read type on a computer or video screen, many of which are discussed in other parts of this book, such as duration and speed. The specific attributes of a typeface that were designed into it to enhance legibility can be altered drastically by the display resolution, and steps may need to be taken in an effort to reduce the effects.

The Univers family demonstrates how the display resolution can be detrimental to weight, width, and posture, reducing legibility in the typeface. Thin-stroked variations, especially the oblique faces, have the most difficulty with the grid-restricted pixel—in some cases the stroke is not even evident. Stroke widths are not consistent, and the counterforms in heavier weight typefaces appear closed. Letterspacing is inconsistent, and some letter combinations will read as one letter when they are too closely letterspaced. Additional tracking can reduce this effect.

Univers Light, 12 point
Univers Light Oblique, 12 point
Univers Regular, 12 point
Univers Regular Oblique, 12 point
Univers Bold, 12 point
Univers Bold Oblique, 12 point
Univers Extra Bold, 12 point
Univers Extra Bold Oblique, 12 point
Univers Condensed, 12 point
Univers Extended, 12 point

Letterform combinations of 'r' and 'n', and 'c' and 'l' at 100 per cent and 200 per cent.

m m
d
d

Specialty effects, such as outlined type and shadowed type, can also pose legibility problems. Script and serif typefaces do not render on the screen as well as sans-serif typefaces do, particularly serif type with a large thick-to-thin stroke variation. Serifs will merge, and in some cases break up or disappear altogether. Non-traditional typefaces, many of which already pose legibility issues because of their irregularities among characters and overly stylized forms, are less successful on the screen than sans-serif typefaces and should be restricted to use as display faces.

outline text
shadow text
Script typefaces
Serif typefaces
SERIF TYPEFACES
Thick - Thin stroked typefaces
Non-traditional typefaces
NON-TRADITIONAL TYPEFACES
Non-traditional typefaces

Film, video, and digital sequences can all be categorized by medium and the numerous formats, display resolution and frame rates that exist (Fig. 07).

The media of film, video, and digital can be categorized into formats. 35mm film-stock, VHS videotape, and the digital media architecture Quicktime™ are examples of formats.

The frame rate refers to the speed of projection (film) or display (video/digital). It is measured in frames per second. 35mm film runs at 24 frames per second (24 fps), which means 24 frames of the film run through the projector per second elapsed. Video is 30 fps (or more precisely 29.97 fps) and 25 fps. Quicktime™ sequences can be any frame rate. Refer to *Technology 03, Animation*, to see how frame rates affect motion.

The display resolution refers to the number of pixels in a horizontal scanline times the number of scanlines. Film itself is not a digital medium and therefore is not measured in pixels, but in dots per inch (dpi). Film is a continuous tone medium, like a photograph. However, creating digital sequences for transfer to film is measured in pixels.

In direct correlation to the measurement of the display resolution is the frame aspect ratio. The frame aspect ratio is the ratio between the width and the height of the frame. Ratios were originally developed based on camera and film-stock limitations. The wider film aspect ratio most imitates the way we literally *see* the world. Because of these technological restrictions, the designer was limited to working within the constraints of one of these predetermined frame aspect ratios.

The digital media architecture Quicktime™ will work in any frame aspect ratio, as long as it is rectangular. This creates more options for designers, but only applies to digital sequences that are for computer display. If the digital sequence is going to be transferred back to video or film, it must stay within the appropriate frame aspect ratio, or be *letterboxed*. Displaying a sequence from one format's frame aspect ratio within another is accomplished by the use of a letterbox: black masking on the top and bottom of the frame.

Video and 35mm film—Academy
Aperture is 1.33:1 or 4:3 ratio

35mm film—European Standard
Widescreen is 1.66:1 ratio

35mm film—American Standard
Widescreen is 1.85:1 or 16:9 ratio

The ratio of 1.33:1 means that the frame's width is 1.33 times wider than its height. These are just three frame aspect ratios, but there are numerous others in film and video, and particularly now with the advent of digital video.

Time Code

Time is measured by time code. SMPTE code is the universal time code for synchronizing analog/digital video and audio equipment. (SMPTE stands for Society of Motion Picture and Television Engineers.) Time is measured in hours, minutes, seconds, and frames. Film can be measured in SMPTE time code, but is preferred measured in feet plus frames.

00:00:00:00
hours:minutes:seconds:frames

0000 + 00
feet + frames

35mm film: 16 frames = 1 foot
16mm film: 40 frames = 1 foot

Color and Broadcasting Systems

To further divide up the various formats of video, there are three color and broadcasting systems used internationally for broadcast television. They differ in frame rate, aspect ratio, resolution, and color quality. To view videotape recordings from one system to the next, standards conversion must take place, which requires special videotape recorders.

NTSC, National Television Systems Committee
29.97 frames per second with a 484 scanline resolution.
Used in North America, parts of Asia, and South America.

SECAM, Séquential Couleur Avec Memoire
25 frames per second with a 625 scanline resolution.
Used in France, the former Eastern Bloc, parts of the Middle East, Asia, and Africa.

PAL, Phase Alternation Line
25 frames per second with a 625 scanline resolution.
Used in most of Europe, China, the South Pacific, Southeast Asia, and parts of Africa.

Title- and Action-Safe

Title-safe and action-safe areas are essential zones for legibility: critical areas within the frame that will not be cropped off when viewed on different video monitors. Different video monitors can crop off the outer edges of the frame, so titles or particular actions that are critical should avoid the edges and stay within the title- and action-safe areas.

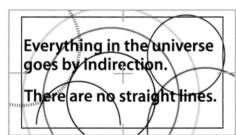

action safe

title safe

Fig. 07, Summary of common technical specifications

Medium	Format	Frame rate		Display resolution (pixels)	
Video (analog)	Videotape	NTSC	PAL/SECAM	NTSC	PAL/SECAM
	UMatic	29.97 fps	25 fps	640 x 480	720 x 576
	Betacam SP	29.97 fps	25 fps	640 x 480	720 x 576
	Video8	29.97 fps	25 fps	640 x 480	720 x 576
	Hi8	29.97 fps	25 fps	640 x 480	720 x 576
	Super VHS	29.97 fps	25 fps	640 x 480	720 x 576
	VHS	29.97 fps	25 fps	640 x 480	720 x 576
Video (digital)	Videotape	NTSC	PAL/SECAM	NTSC	PAL/SECAM
	D1/D2	29.97 fps	25 fps	720 x 486	720 x 576
	Digital Betacam	29.97 fps	25 fps	720 x 486	720 x 576
	Betacam SX	29.97 fps	25 fps	720 x 486	720 x 576
	DVCAM/DVC Pro	29.97 fps	25 fps	720 x 486	720 x 576
	Mini DV	29.97 fps	25 fps	720 x 480	720 x 576
	Digital8	29.97 fps	25 fps	720 x 480	720 x 576
Film (analog)	Film Stock				
	35mm	24 fps		2048 x 1536 , 1234, 1152	
	Super 16mm	24 fps		2048 x 1234	
	16mm	24 fps		2048 x 1536	
	Super 8mm	18/24 fps		-	
	8mm	18/24 fps		-	
Digital sequence	Quicktime™				
	Macintosh and Windows	Any, 15/30 fps are common		Any, common in 4:3 ratio:	
	AVI			640 x 480, full screen	
	Windows only	Any, 15/30 fps are common		320 x 240, 1/2 screen	
				240 x 280, 1/3 screen	
				160 x 120, 1/4 screen	

Digital Audio

Digital audio is measured in sampling rates and bit resolution, which determine dynamic range. Digital audio can be either mono or stereo. Higher sampling rates and resolutions result in larger file sizes and a need for faster computer processing and storage, but provide a cleaner and better quality sound.

Bit resolution (sample size) can be16-bit, 12-bit, or 8-bit. Typical sampling rates are 44.1 kHz, 32 kHz, 22.050 kHz, and 11.025 kHz. Compression schemes can be utilized with digital audio to reduce the file size (megabytes) without much loss of quality. Which sampling rate and bit resolution is the most effective and appropriate for the audio component of your sequence is determined by the final format destination—film, video, Internet, CD-ROM, etc.

Fig. 08, Title animation cue

Title animation cue example for title cards (in frames)

title#	title	effect	length	from	to
1	Written by	fade-in	36	1	36
		hold	144	37	181
		fade-out	36	182	218
		black	12	219	231
2	Directed by	fade-in	36	232	268

Title animation cue for title crawl (reset to frame 1)

title#	title	effect	length	from	to
		black	75	1	75
credit	A Film by	fade-in	36	76	112
		hold	100	113	213
		move	2800	214	3014
		black	75	3015	3090

There are a number of technologies involved in producing moving type, both analog and digital, and combinations. While digital technology is slowly becoming the norm, many traditional methods, particularly in film, offer what are the most effective and inexpensive solutions.

Title Cards

Title cards were initially the only method for putting type on the screen. The type was printed on a *card* which was filmed directly into the video or film camera.

Super cards took title cards a step further. The type was still printed on a card and exposed into the camera, but the title was *superimposed* over an image. This method also employed *keying* the titles over the image (called key cards), a process which involved eliminating the background color of the title card, leaving only the type layered over the image. Keying is still a viable method for layering type and image, and multiple images, in video and digital media.

Line Negatives and Burn-In Titling

Film-production methods utilize a superimposition over image or classic white titles on black background process using a line negative of the titles. Type can also be exposed onto the image. The title area is *burned* with light through the background. In processing, all emulsion in these areas is wiped out. You get the illusion of superimposed white lettering over action.

End-title Crawls

A crawl (also called a scrolling list) was prominent in video production, but is still used regularly in film production. The type is printed on a long, scroll-like sheet of paper or negative film and attached to a large drum, which is rotated in front of the camera or exposure unit. When producing a crawl, it should be shot to move steadily, giving each line equal time on screen. It should take a line of type, set correctly, 7–10 seconds to scroll from its entry to its exit in the frame for a comfortable read. This timing also applies to crawls animated digitally.

Title Animation Cue

When titles are going to be exposed onto film or video using one of these traditional processes, a title animation cue is necessary before the titles can be shot by the production company. It includes the length, in frames for film and SPMTE code for video, of a title's timing. This includes fade-in, hold/duration, fade-out, and black interval to the next title (Fig. 08).

Character Generators

Character generators were early typesetting devices in which the titles were typed in and could be superimposed onto the video image without title cards, in essence the forerunner of the computer. Very little control over the characteristics of the typography was allowed by these machines beyond typeface, point size and leading, and horizontal positioning.

Digital Dominance

Computer hardware and software is slowly making most of the previous processes obsolete (although old processes can be utilized in creative ways), and is the most effective technology for designing for the Internet. There is a range of hardware platforms and software packages available for animating and compositing typography. Most come with a number of special effects, which should always be used with caution (avoiding form for form's sake). They range from high-end systems found in film and video production facilities (Flame™, Avid Media Composer™, EditBox™, Alias/Wavefront™, Softimage 3D™, Maya™) to desktop computer software, less expensive but very powerful tools (Adobe's After Effects™ and Premiere™, Macromedia's Flash™ and Director™).

Space Type Time

Space Type Time is divided into three sections. The first section—Space—establishes groundwork of spatio-temporal typography. Here, we begin with the elements of structuring and framing space. The second section—Type—demonstrates those fundamentals which alter the very structure characteristics of letterforms, up to the form of words and sentences. This section also addresses the use of supporting elements (shapes, images, sounds) in spatio-temporal communication. The third section—Time—addresses the aspects of kinetics and sequencing.

The fundamentals presented in Space Type Time were developed as a means of gaining an understanding of and teaching spatio-temporal typography in relationship to appropriate, creative, and effective visual communication. They build upon the fundamental principles that underlie good typography, which alone cannot adequately address type in motion.

The sequence examples in Space Type Time are intentionally simple in order to effectively demonstrate specific fundamentals. The sans-serif type family, Myriad, is used as the standard for demonstration due to its stripped-down, yet refined, structural features. The fundamentals do not address specific media such as film title, television broadcast, or web design, but instead are intended to function as a foundation upon which the designer may build his or her understanding of spatio-temporal typographics and apply it to whatever medium they may find themselves involved in.

The best ideas are common property.

Seneca, *Epistles*, first century AD

The fundamentals primarily focus on the formal manipulation of typography. Form can inform, enhance, and express content. The use of image and audio are addressed as structurally supportive devices, with the typography as the main focus. The study of the moving image and sound is too vast to be addressed in the limited space of a single book.

Moving type is more often than not most successful when presented in individual word or phrase sequences because computer and television screens are an inferior medium for reading long and involved text. Just as we have certain expectations from a book—permanence, a contemplative text on which one can review and meditate—animated typographic sequences are best presented in the form of short sentences or phrases designed to ask a question, simply point in a direction, or provide visual 'sound' bites. The experience of the viewer also changes with presentation. Text that is divided into phrases and words engages in a sort of dialog with the viewer, giving the experience of being spoken to. Larger bodies of text appearing on the screen is closer to the experience of print, and the experience is one of reading.

Finally, many of the animations contain text taken from aphorisms—short statements of truth. It is appropriate for these fundamentals to be applied in the context of words and sentences which have some meaning so that they may be demonstrated appropriately.

Point, Line, Plane, and Volume

There are four conceptually driven elements of space that are beneficial to the graphic designer to understand when designing for the screen: point, line, plane, and volume. There is every reason for a designer who works in time-based media to have an understanding of space beyond the two-dimensional surface. The screen confines moving objects to a defined flat surface, but the perception of space exists nonetheless.

Because we live in a three-dimensional world, we can perceive the concept of space quite easily and, in many ways, better than that of a flat, two-dimensional surface. It is the difference between thinking *sculpturally* and *pictorially*. The principles of three-dimensional design are important to time-based media.

Point

A point indicates a position in space and occurs at each end of a single line. A point can also be found where lines intersect, and where lines meet at the corner of a plane. A point has no length, depth, or width.

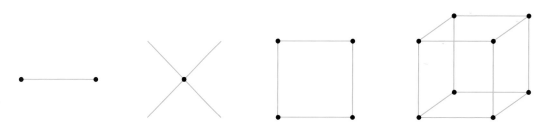

A **point** indicates a position in space and occurs at each end of a single line. A **point** can also be found where lines intersect, and where lines meet at the corner of a plane. A **point** has no length, depth, or width.

Line

As a point moves, it creates a path which is a line. In the simplest sense, a line is defined by at least two points in space. A line has position and direction, it defines the edge of a plane and exists where two planes intersect or join each other. A line has length, but does not have depth or width.

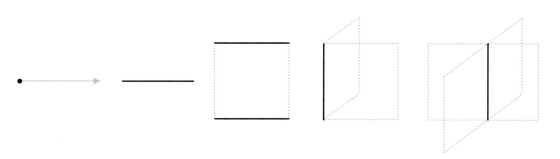

As a point moves, it creates a path which is a line. In the simplest sense, a line is defined by at least two points in space. A line has position and direction, it defines the edge of a plane and exists where two planes intersect or join each other. A line has length, but does not have depth or width.

Plane

As a line moves in a direction other than its own intrinsic direction, it creates a path which is a plane. A plane is defined by at least one line. A plane, bound by lines, defines the external limits of a volume. A plane has length and width, but does not have depth.

As a line moves in a direction other than its own intrinsic direction, it creates a path which is a plane. A plane is defined by at least one line. A plane, bound by lines, defines the external limits of a volume. A plane has length and width, but does not have depth.

As a line moves in a direction other than its own intrinsic direction, it creates a path which is a plane. A plane is defined by at least one line. A plane, bound by lines, defines the external limits of a volume. A plane has length and width, but does not have depth.

As a line moves in a direction other than its own intrinsic direction, it creates a path which is a plane. A plane is defined by at least one line. A plane, bound by lines, defines the external limits of a volume. A plane has length and width, but does not have depth.

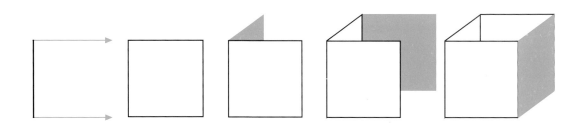

Volume

As a plane moves in a direction other than its own intrinsic direction, it creates a path which is volume. Volume defines the space contained within it or displaced by it. Volume has length, width, and depth.

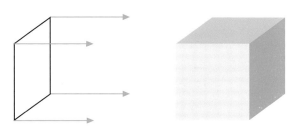

As a plane moves in a direction other than its own intrinsic direction, it creates a path which is volume. Volume defines the space contained within it or displaced by it. Volume has length, width, and depth.

As a plane moves in a direction other than its own intrinsic direction, it creates a path which is volume. Volume defines the space contained within it or displaced by it. Volume has length, width, and depth.

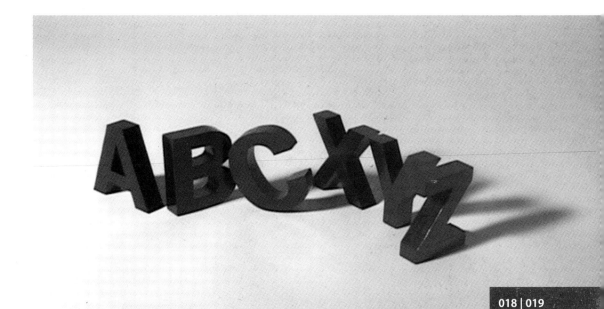

Perspective

Geometric or linear perspective was developed by three artists working in the Early Renaissance (fifteenth-century Italy): Masaccio, a painter; Donatello, a sculptor; and Brunelleschi, originally a painter and later an architect. The system is based on converging parallels. It employs a horizon line, which divides the picture plane into ground plane and sky plane (much like looking out the window of a house), and a vanishing point, the point at which the parallels converge.

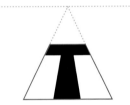

Traditional drawing uses a system based on the geometry of converging parallels to create the illusion of three-dimensional objects on the two-dimensional surface of the picture plane, known as one-, two-, or three-point perspective. The establishment of a foreground and background is created through value, contrast, scale, and color variations between objects, and enhances the manipulation of space.

It is important when designing for time and space that one views the frame with an understanding of perspective. Do not look at the frame as merely a flat two-dimensional surface on which to design, rather approach the composition as if looking through the lens of a camera.

One-point Perspective

One-point perspective is used to render an object as if one face is parallel with the picture plane. One-point perspective is achieved through repetition and a reduction in scale, and utilizes a single vanishing point.

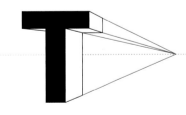

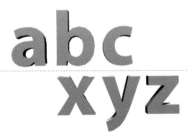

Two-point Perspective

Two-point perspective is used to make an object appear to be at an angle to the lines of sight, or at an angular position in depth on the picture plane. Two-point perspective utilizes two vanishing points.

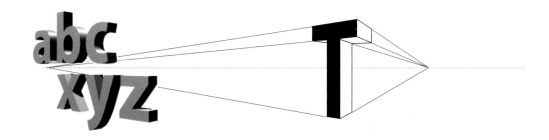

Three-point Perspective

Three-point perspective, consisting of a third point above eye level, is used to illustrate a tall object that recedes upward in space, like a skyscraper, or to give a view down along an object that appears to become smaller as it recedes below the eye level of the observer.

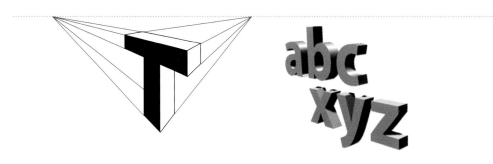

Cartesian Coordinate System

Another way to look at perspective within the screen is through the Cartesian coordinate system, which is defined by a set of mutually perpendicular axes. An axis is an imaginary straight line that defines the center of a body or geometric object, and is the centris around which this object may rotate. The X-axis is horizontal, the Y-axis is vertical, and the Z-axis is spatial (advancing or receding).

We can also differentiate the space into three planes of composition: the frame plane, the depth plane, and the geographical plane. Composing the frame in three-dimensions in this way is similar to how a film-maker looks through the lens of a camera.

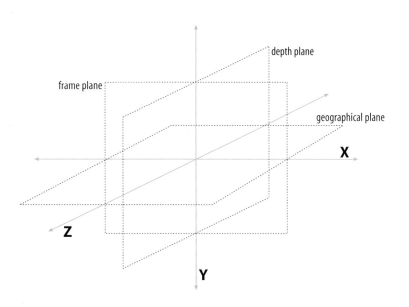

Aspect Ratio

Composition

Ground

Depth

Grid

Mask

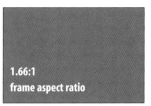 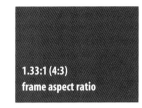 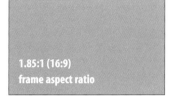

1.33:1 (4:3)
frame aspect ratio

1.66:1
frame aspect ratio

1.85:1 (16:9)
frame aspect ratio

Frame Aspect Ratio

The active composition space in relation to the screen is known as the frame. The frame in film refers to both the image on the film and the dimensions of the projected screen. The frame in video refers to the video monitor itself. The frame in digital media refers to the rectangular bounding area that confines the sequence.

The frame aspect ratio is the ratio between the width and the height of the frame. Three common frame aspect ratios are 1.33:1, or 4:3; 1.66:1; and 1.85:1, or 16:9. These ratios were originally developed from camera and film stock limitations. The wider film aspect ratio most imitates the way we literally *see* the world. Because of these technological limitations, the designer was formerly limited to working within one of these frame aspect ratios.

The digital media architecture QuickTime™ will work in any frame aspect ratio, as long as it is rectangular. This creates more options for designers who are accustomed to having the choice of varying the dimensions of their work surface to accommodate a solution.

Frame aspect ratios should be carefully considered with regards to production and display technologies as well as content. An extremely horizontal aspect ratio can be used to emphasize *distance* because we see a horizontal rectangle as a landscape (001|023). A vertically-oriented sequence can support the concept of *height* or *falling* (002|023).

001 | 022 Frame: horizontally extended

002 | 022 Frame: vertically extended

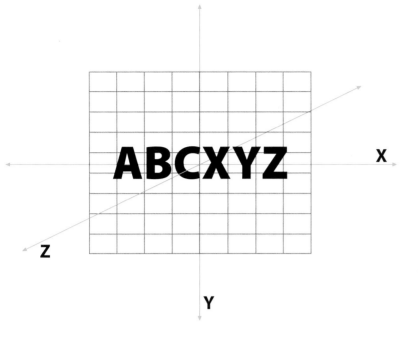

Fig. 01, Frame as room (containing)

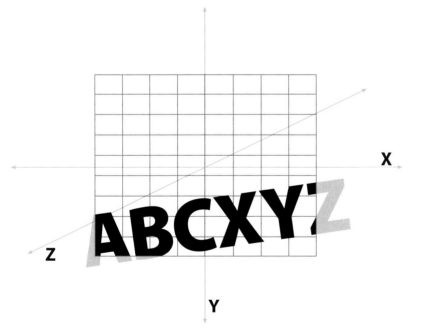

Fig. 02, Frame as window (capturing)

Composition

The frame is also an important compositional device in that it defines the borders of the active viewing space. A frame can serve as a *room* that contains elements. Here the borders are perceived as solid walls. Similar to furniture in a bedroom, the elements are fully in the active space and have nowhere to move but within the borders (Fig. 01).

A frame can also serve as a *window* that looks out into a larger space. The borders capture elements—in part or whole—as they move through the larger space. Only those elements captured within the borders are seen by the viewer, but the viewer senses a larger space of activity beyond the borders (Fig. 02).

Ground

Ground can be categorized as *planar ground* and *linear ground*. Planar ground is the relationship between the background plane within the frame and the object in the foreground (in this case typography). This is often referred to as the figure-ground relationship. Planar ground relationships play an important role in establishing a foreground and background by causing the type to advance or recede, depending on the contrasts of hue and value. The greater the contrast between the type and its ground, the more the ground will appear to recede and the type will appear to advance.

Altering planar ground over time produces an optical effect of advancing and receding type, even though the letters do not change in scale (003|024).

003 | 024 Planar ground

Linear ground refers to the relationship of the object (typography) to the viewer, based on an assumed camera angle (as if the object was being viewed through a camera). In cinematic terms, the linear ground (often called the horizontal plane) refers to the typical way in which humans see everything level. A film-maker can turn the camera in such a way as to alter the linear ground, which creates a tension between the viewer and the film image.

Altering the linear ground in a typographic sequence creates tension as well, albeit a more formal tension as opposed to a narrative one. The horizontal plane can be level, tilted, or altered over time. Combining an increasing scale change with a tilted horizontal plane can produce the effect of moving or flying through the typography (004|025).

004 | 025 Linear ground

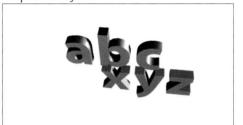

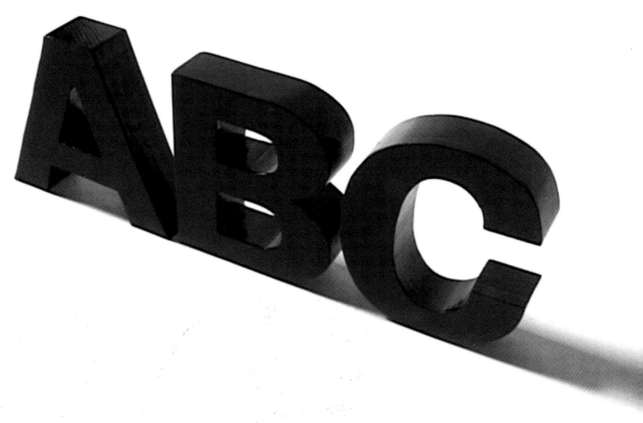

Aspect Ratio

Composition

Ground

Depth

Grid

Mask

Depth

Scale is the most obvious determinate of depth; the larger the scale of the type is in relationship to the frame, the closer it will appear to the viewer. Conversely, smaller type will appear at a further distance. Depth can be enforced further by contrasts of the tonality and value of the letterforms. No longer limited to small versus large, altering scale over time creates a hierarchy based on advancing versus receding type (005|026, 007|026).

The distance between the farthest and nearest points that appear sharp (in focus) through the lens of a camera is called the *depth of field*. Controlling depth of field, which is an important aspect of photography and film-making, also becomes an integral factor for the establishment of depth within the frame.

Shallow focus is when the object in the foreground (closest to the lens of the camera or the frame of the animation) is in focus, while the object in the background (farthest from the lens of the camera or the frame of the animation) is out of focus. Deep focus is when the object appearing in the background is in focus, while the foreground is out of focus (006|026).

005 | 026 Scale

007 | 026 Scale

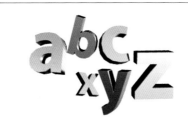

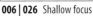

006 | 026 Shallow focus

Shallow focus

Deep focus

Deep focus

Grid

Animating typography can often be daunting, particularly for the beginner, as there are so many composition variables. The grid is an organization system that print designers have used for years; it is also effective for the visual organization of a time-based sequence.

The use of a grid is helpful even though many words and letters do not appear within the frame simultaneously. Visual organization can assist the viewer to see and read the sequence without missing relevant information.

If the viewer's eye must constantly move around the frame in order to read the text, communication breakdown will result. The elements of proximity and grouping address this further.

This sequence was designed using a very simple grid and alignments. It also stays within the safe boundaries (008|027).

Mask

Masking is one technique that perceptually alters the rectangular frame boundaries. Masks allow the designer to simulate a non-rectangular geometric frame (009|027), or even an organic frame (010|027). This effect can be further improved upon if the color of the computer monitor's desktop is the same as the masked areas of the frame.

008 | 027 Grid

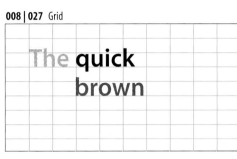

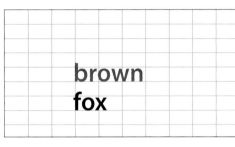

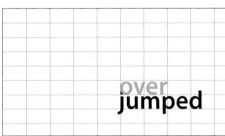

009 | 027 Mask

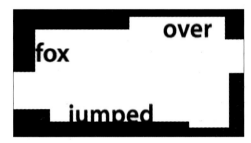

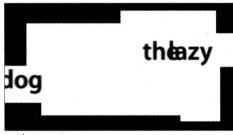

010 | 027 Mask

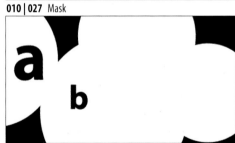

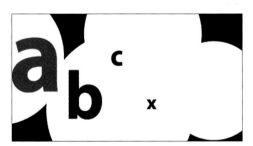

Human visual perception is based on the trichromatic theory of color. There are three basic color systems, each of which is comprised of three primary hues. Hue is another name for color. Equal amounts of the three primary hues in each system combine to create secondary, or complementary hues. Each system is capable of creating the millions of colors that exist.

The Color Wheel

The first system is based on the three primary hues red, blue, and yellow, as shown in the basic color wheel. The secondary hues are orange, green, and violet. The color wheel also shows six tertiary hues, formed by mixing equal amounts of a primary hue and an adjacent secondary hue. This system is based on mixing color pigments.

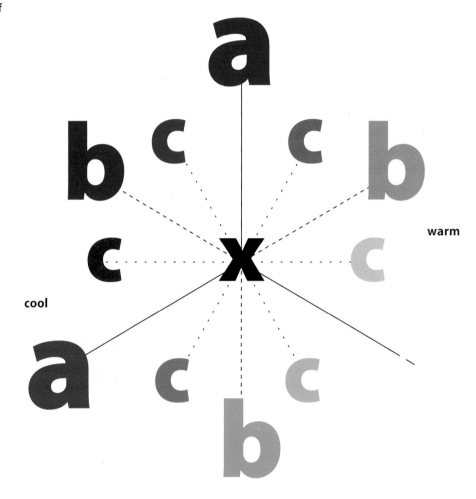

warm

cool

Primary hues

Secondary hues

Tertiary hues

Subtractive Color System

The second system is the subtractive system, based on the primary hues of cyan, magenta, and yellow (CMY), commonly used by printers. The complementary hues are red, blue, and green. Equal mixtures in intensity of the three primary hues in the subtractive system combine to form black. The subtractive system works by reflected light. It is how we see color on a surface, such as paper. The light reflects off the surface, which reflects certain wavelengths and absorbs others.

011 | 029 Subtractive color system

Primary hues
Cyan
Magenta
Yellow

Secondary hues
Blue
Red
Green

**Equal mixtures
form black**

Additive Color System

The third system is the additive system, based on the primary hues of red, green, and blue (RGB), which are the primaries of light. The complementary hues are cyan, magenta, and yellow. Equal mixtures in intensity of the three primary hues in the additive system combine to form white, while the absence of all three produces no color (black). The additive system works through direct projected light, light that is visible from the source, such as light bulbs, the sun, and video and computer monitors.

012 | 029 Additive color system

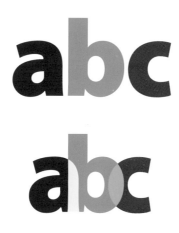

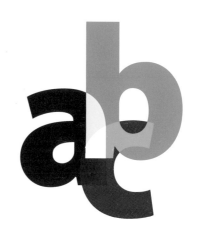

Primary hues
Red
Blue
Green

Secondary hues
Cyan
Magenta
Yellow

**Equal mixtures
form white**

Color Resolution

In Technology 01, legibility, pixels, and bitmaps were discussed in relation to type resolution. The number of bits also directly determines the color resolution, or the number of color variations that the computer monitor is capable of displaying.

1 bit	black and white
2 bits	4 colors or 4 shades of gray
4 bits	16 colors or 16 shades of gray
8 bits	256 colors or 256 shades of gray
16 bits	32,000 colors
24 bits	16.7 million colors
32 bits	16.7 million colors plus alpha channel

The properties of color include brightness, saturation, temperature, and contrasts.

Brightness

Brightness, also referred to as value, is how light or dark a hue is. A hue's intrinsic brightness increases with the addition of white, called a tint, and decreases with the addition of black, called a shade. It is important to note that color created from light, the additive system, like the color on the video or computer monitor, is unable to present colors with the same intensity as color created from pigment.

Tints are created with the addition of white, increasing the intrinsic brightness of the color

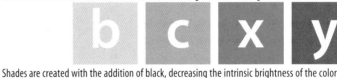

Shades are created with the addition of black, decreasing the intrinsic brightness of the color

Saturation

Also referred to as chroma or intensity, a hue's saturation refers to the strength of a hue added to its pure brightness. A pure hue, with no other colors mixed in, is the purest form. Saturation is affected by the addition of another color, or the juxtaposition of two complementary colors.

The intensity that is the result of the juxtaposition of two complementary colors is called simultaneous contrast. On the screen this intensity is amplified, it will appear as vibrating to the human eye. These examples are from the additive RGB color system, where the primary hues are red, blue and green, and the secondary hues are cyan, magenta, and yellow.

Temperature

Hues can create the physical and emotional reaction of temperature. Reds, oranges, and yellows connote warmth, while blues, greens, and violets connote cool temperatures.

Warm hues are less suitable as backgrounds on screen than cool hues, because a warm hue will increase intensity and thereby increase the chance of color vibration to occur.

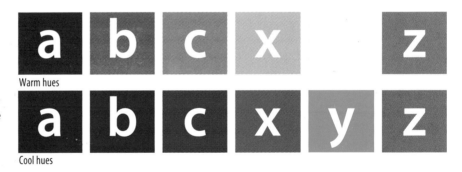

Warm hues

Cool hues

Contrasts

The vibration of colors on the video or computer screen is caused by too drastic a contrast between type and its background, and is an important factor in determining legibility. Strong color contrasts create distracting vibrations, and subtle contrasts will create type difficult to see. Black backgrounds create the least amount of this vibration—type on television and in film credits has historically almost always been white text on a black background. The opposite is true of print, where black type on white background is the most legible.

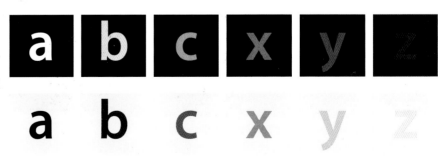

If light-colored type is used on a darker screen background, the type will appear slightly larger and bolder than dark type on a lighter background. In the first case, the type expands into the darker, surrounding color. In the second case, the lighter-colored background expands over the type.

Typographic Factors

Attributes of a particular typeface can also pose legibility problems, particularly when the contrast between the background and type is too subtle or too strong.

Typefaces with very thin strokes or a narrow width, or of a very small size, create reading difficulties on the screen. Extreme color contrasts that further impede legibility should be avoided.

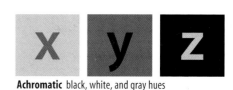

Color Relationships

Other hue relationships exist in addition to the primary, secondary, and tertiary relationships already discussed. The examples to the right are from the additive RGB color system, where the primary hues are red, blue, and green, and the secondary hues are cyan, magenta, and yellow.

Monochromatic a single hue and its tints and shades

Achromatic black, white, and gray hues

Complementary any two hues directly opposite to each other on the color wheel

Split complementary a single hue and the two hues on either side of its complementary

Analogous hues adjacent to one another on the color wheel

Neutral a single hue and a percentage of its complementary or black

Color Gamut

The range of displayable colors, called the color gamut, differs between the computer and video monitors. Similar to the vibration, the simultaneous contrast of hues created by oversaturation of color will result in color bleeding on a video screen. Saturated reds are the worst victim of video bleeding. Small type is also prone to bleeding on a video screen. The range of colors that are not prone to bleeding are called video-safe or broadcast colors. Saturation and luminance of a hue can be adjusted to make a color video safe.

Color bars are used as a color standard by the television industry for the color alignment between different cameras, monitors, and recordings. When distributing sequences on videotape, a minimum of 10 seconds of color bars should be recorded at the beginning.

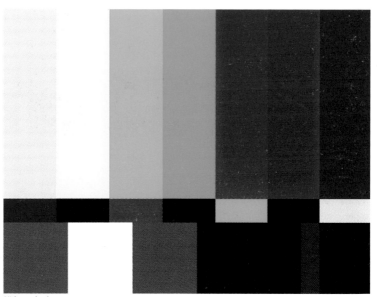

Video color bars

Interpretation

It is important in the context of typographical sequences to possess an understanding of how we interpret the words we read, normally fixed and static, and how we interpret the images we view in a sequence (film and video), since the two have inevitably collided and subsequently merged in moving type.

The interpretation of words, images, and sounds are *denotative* and *connotative*. A denotative interpretation is an explicit, specific indication of a word, image, or sound—it is self-referential or iconic, and the viewer does not necessarily have to work to recognize it. A connotative interpretation is implicit and suggests or implies.

Language is a flexible system. Letters are utilitarian symbols used to represent language and have no meaning until they are assembled into words. A word is a sequence of symbols to which meaning is applied. In most cases a word does not look like the idea it implies. The word possesses a sound (when spoken) and physical existence (what is seen). When the word is read, a mental image is created. Letters are at once representations of themselves and symbols for concepts when assembled into words and sentences.

In an image-based sequence, one reads an image differently from the way a word is read in a text. For example, the word *baby* connotes an image which may or may not be the same as someone else's image. An image of a baby on the screen, however, is the same baby everyone else sees. The image does not suggest, in this context: it denotes or states.

When we read a word that exists within a complete sentence, two types of connotation exist. In the first, we compare the letters of the word to each other to form the word. We then compare the word to the other words in the sentence to form a complete thought. The process continues as we compare sentences, paragraphs, and chapters to complete a whole.

At the same time, we are comparing these words, sentences, etc. to elements that exist outside the book itself, in the paradigm. The meaning is not necessarily derived from the words we see, but from a comparison of those words to what we don't see. Our social and cultural persona enters, we make associations from what we know and understand already, our influences.

The same two types of connotation exist when we view images in a sequence. The meaning of a specific shot is derived from the shot being compared to shots that precede and follow it. At the same time, we are making associations to elements that exist outside the frame, in the paradigm.

Point, line, plane, and *volume* are conceptually tied to both the structure and composition of typography and narrative sequences (film and video). In filmic terms, a frame is defined as the shortest moment in time captured on film. A shot is a continuum of frames composing one action. A scene is a series of shots edited together, but only existing as one component of the narrative. A series of scenes is edited together to compose a complete narrative sequence.

Point	Word	Frame
Line	Sentence	Shot
Plane	Paragraph	Scene
Volume	Text	Sequence

The letters: **gosabuimu**

The word: **ambiguous**

The concept: **a m g o u b i u s**

The word: **baby**

The image:

Intonation

Expression of meaning can be accomplished through intonation, which refers to the modulation of a voice—the tone of voice when someone is speaking. Words can be animated to simulate intonation the way an actor might speak them, or to support the definition of a word (013|033). Various formal devices introduced throughout this section are employed as examples of ways to accomplish intonation.

happiness

ANGER

ANGER

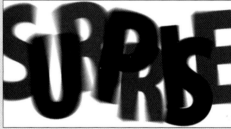

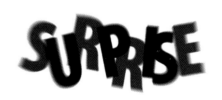

hesitation

hesitation

SURPRISE

Characteristics

Case
Face
Posture
Width
Weight
Scale

Letterform Characteristics

The particular characteristics of letters can be altered sequentially to bring attention to the meaning of a word, phrase, or sentence; to create visual hierarchy; or simply for formal experimentation. Transitions between the characteristics of a letter or word can also be used to emphasize the *voice* of the speaker in a situation where dialog is being read, spoken, or both.

Case

Uppercase letters traditionally mark the beginning of a sentence, and tend to possess a monumentality in form, which in turn gives emphasis and importance to a word. Lowercase letters form recognizable and distinct word shapes due to the variety of letter shapes, ascenders, and descenders, providing a contrast which benefits legibility. Attention is given to *NO STYLE* by the transition from lowercase to uppercase (014|034).

Face

Type is categorized into two large categories, serif and sans-serif, but infinite variations exist within each group. The visual character of a typeface, which differentiates it from other typefaces, can give a word a particular personality. Altering typeface choice (014|034) in rapid editing plays with the notion of *style*.

014 | 034 Case

Style is nothing, but nothing is without style.

Style is nothing, but nothing is without style.

Style is nothing, but NOthing is without style.

Style is nothing, but NOthing is without STYLE.

015 | 034 Face

Style is nothing, but nothing is without style.

Style is nothing, but nothing is without **style.**

Style is nothing, but nothing is without style.

Style is nothing, but nothing is without style.

Style is nothing, but nothing is without style.

This sequence uses the typefaces Myriad, Dogma Outline, Keedy Sans Regular, Remedy Double, FFErik Righthand, Dead History Roman, Bureau Grotesque ThreeSeven, Serifa Roman, Bodoni Regular, Univers 55, and Minion Display.

Posture

Sequence 016|035 transitions from the upright
to the italic version of the typeface Myriad to
alter its posture, or stance. Italic and oblique
typefaces possess a kinetic quality because of
their slant to the right. Animating the
transition over time from upright to oblique
makes the kinetic quality even more dynamic.

Width

The proportion of a letterform relative to its
height is known as its width. The greater the
width of the letterform, the larger the
counterforms and intervals of white between
the strokes. The process of scaling the words
horizontally and vertically gives them a life of
their own (017|035).

Weight

The thickness of the stroke relative to the
height determines the weight of a letter.
Enhancing the meaning of the aphorism
(018|035), the ability to transition the word
nothing from bold to lightweight supports the
concept that *Style* is becoming *nothing,* while
transitioning the word *without* from bold to
extra bold gives added emphasis.

Scale

Visual hierarchy is most easily achieved in
altering the scale of words and letters on the
screen. The diminishing scale of the words
further emphasizes *nothingness,* while the
increasing scale of *style* makes a forceful
statement (019|035). Large and small are
relative to each other and most evident in a
sequence when the scaling occurs over time.
This also affects the spatial relationships
between letters and words.

016 | 035 Posture

Style is

Style is

Style **is nothing, but nothing is without** style.

Style **is nothing, but nothing is without** *style.*

017 | 035 Width

Style is nothing, but nothing is without style.

Style is nothing, but nothing is without style.

018 | 035 Weight

Style is nothing, but nothing is without style.

Style is nothing, but nothing is without style.

Style is nothing, but nothing is without style.

019 | 035 Scale

Style is nothing, but nothing is without **style.**

Style is nothing, but nothing is without **style.**

Distortion

Elaboration

Dimensionality

Distortion

Distorting typography can be accomplished in many ways, and most animation software programs give easy access to filters which allow an array of visual effects to be applied. Distortion transforms letters and words from symbols into images. Visual effects can be effective, but if overused will be perceived as mere surface treatment or veneer, designed simply to please the eye, regardless of underlying meaning.

Distorting letterforms through blurring, fracturing, and cropping can result in active compositions (020|036, 021|036, 022|036). Blurring and fracturing (023|036) can extend the meaning of the text when the effects occur over time.

Specialty effects of distortion refer to those effects requiring the use of specific software filters, such as pinch, ripple, wave, spherize, and twirl (024|036).

020 | 036 Distortion: blur

021 | 036 Distortion: crop

022 | 036 Distortion: fracture

023 | 036 Distortion: blur, fracture

024 | 036 Distortion: specialty

Elaboration

Elaboration of letters and words can be an effective method for creating visual hierarchy or emphasis. Isolating words by changing the color (025|037), and in this example flashing the word for added emphasis or enclosing with shapes (026|037) are examples of elaboration. Other forms of elaboration include negation (027|037); outline (028|037); subtraction (029|037); repetition of words (030|037); and extension of the strokes of the letterforms (031|037).

To witness elaboration occur, such as the disappearance of the word *forget,* can be a powerful method to extending the meaning of the message.

025 | 037 Elaboration: color

> **The danger of success is that it makes us forget the world's dreadful injustice.**

> **The danger of success is that it makes us forget the world's dreadful injustice.**

> **The danger of success is that it makes us forget the world's dreadful injustice.**

026 | 037 Elaboration: color, addition

> **The danger of success is that it makes us forget the world's dreadful injustice.**

027 | 037 Elaboration: negation

> **The danger of success is that it makes us forget the world's dreadful injustice.**

028 | 037 Elaboration: outline

> **The danger of success is that it makes us forget the world's dreadful injustice.**

029 | 037 Elaboration: subtraction

> **The danger of success is that it makes us forget the world's dreadful injustice.**

> **The danger of success is that it makes us forget the world's dreadful injustice.**

> **The danger of success is that it makes us forget the world's dreadful injustice.**

030 | 037 Elaboration: repetition

> **The danger of success is that it makes us forget the world's dreadful injustice.**

031 | 037 Elaboration: extension

Distortion

Elaboration

Dimensionality

Realism is a corruption of reality.

Wallace Stevens, 'Adagia', *Opus Posthumous,* 1957

Dimension: surface simulation

033 | 038 Dimension: shadow

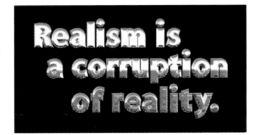

Dimensionality

Surface simulation, *shadow*, and *extruding* letterforms are all methods of creating dimension in letters and words. These methods of creating illusory space are most commonly seen in broadcast-television graphics.

Historically, extruding ornamental and display type by referencing perspective was a common method of eluding to the dimensionality of letterforms. The simulation of shadow is another treatment that establishes dimension.

The wooden letters below (032|038) were videographed to demonstrate that not all dimensional typography need be computer-generated. Before the advent of computer animation, three-dimensional letterforms were often handmade and photographed with a camera.

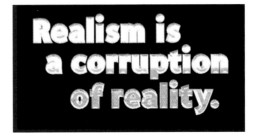

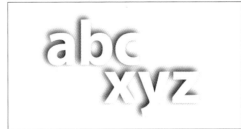

032 | 038 Dimension: shadow

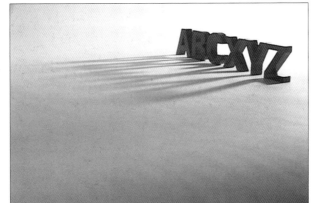

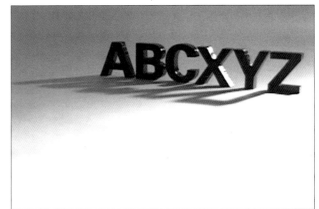

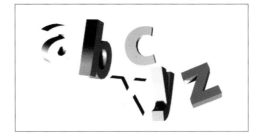
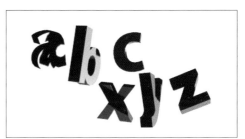
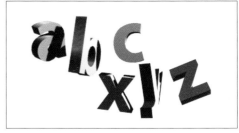

Creating a shadow behind letters and words gives the illusion that they are suspended in a three-dimensional space. The relative hardness—definition—of a shadow can simulate a direct light, while the relative softness—lack of definition—simulates a bounced or fill light. Shadows can also be used in ways that play with our visual perceptions or create an interesting visual effect (033|038).

Extruded letterforms appear to float in space because their direction is varied, and are further enhanced by the changing position of the light source, which causes the letterforms to cast shadows on each other (034|039).

When used creatively, shadows can also function as the letterforms.

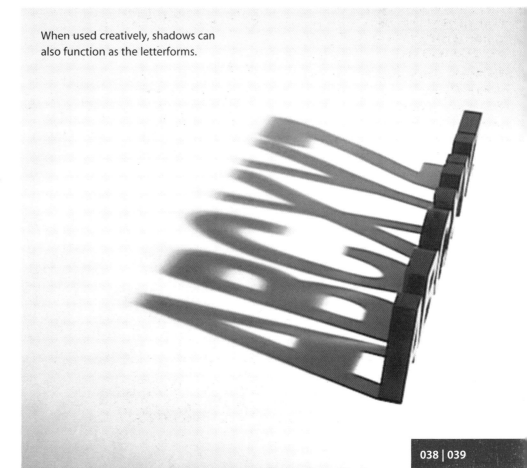

Line

Symbol

Shape

Image

Audio

036 | 040 Line

Everything in the universe goes by indirection.

There are no straight lines.

Everything in the universe goes by indirection.

There are no straight lines.

Everything in the universe goes by indirection.

There are no straight lines.

Everything in the universe goes by indirection.

There are no straight lines.

037 | 040 Line, Shape

Everything in the universe goes by indirection.

There are no straight lines.

Everything in the universe goes by indirection.

There are no straight lines.

Everything in the universe goes by indirection.

There are no straight lines.

Everything in the universe goes by indirection.

There are no straight lines.

Line, Symbol, Shape

The use of ruled lines, symbols, and shapes can have dynamic and highly active relationships with words and letters. They can establish visual hierarchy, rhythmic patterns of movement—especially when there is an audio track—create visual focal points, suggest direction, and define typographic space (035|040, 036|040, 037|040).

The kinetic addition of analphabetic symbols (038|040) creates a lively interpretation to this aphorism. A parenthesis and brace from the Bodoni type family provide entry to the text, while the exclamation point and asterisk add visual activity.

Shapes are capable of connoting meaning—the bubbling up of circular forms to reveal the reversed type or the rectangles tumbling into an architectural form, creating stability for the message (039|041).

035 | 040 Line

Everything in the universe goes by indirection.

There are no straight lines.

Everything in the universe goes by indirection.

There are no straight lines.

038 | 040 Symbol

Everything in the universe goes by indirection.

There ar

Everything in the universe goes by indirection.

There are no straight lines.

Everything in the universe goes by indirection.

There are no straight lines.

Everything in the universe goes by indirection.

There are no straight lines.

Everything in the universe goes by
indirection. There are no straight lines.

Ralph Waldo Emerson, 'Works and Days',
Society and Solitude, 1870

039 | 041 Shape

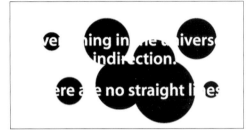

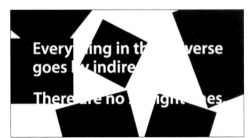

Image

The use of imagery in typographic sequences deserves considerably more attention than this book can provide. Here, imagery is considered as a supporting element to the primary role of typography in message delivery. Images can be visually manipulated in many ways, a few include duotone (079|055), line art (080|055), continuous tone (081|056), and posterization. All of these are examples of literal use of imagery. Abstract imagery (082|056) can function as an effective background to typography when a literal interpretation of the image is not desired. Imagery can be *actual*, appearing as full motion video or film, or *animated,* as a sequence of still images animated.

079 | 055 Image: duotone treatment, literal

080 | 055 Image: line art, halftone treatment, literal

Image: line art, posterization, literal

082 | 056 Image: continuous tone, abstract

Audio

A designer may be in a position to make typographic and editing decisions in response to the audio component of a sequence. The timing of designing to audio (editing) requires a special time sense, which takes experience and study to acquire. All designers should gain an understanding of the impacts sound can have, and should consider audio as integral to the message as image and type (see page 60, *Rhythm and Pace*).

For example, the opening titles for the film *West Side Story*, designed by the legendary Saul Bass, contained a two-minute visual overture synchronized to the theme of the main song, providing a theatrical atmosphere, establishing the visual character of the film, and emotionally preparing the audience for what follows.

Like imagery, sound can be categorized as literal or abstract. Literal sound is referential and is necessary to support reality. It conveys a specific meaning. Examples are words spoken by an actor or sounds associated with environments. It may or may not point to the originating source—we may or may not actually see the actor speaking.

Abstract sound, such as a musical score, is not essential to the content of a sequence, does not point to the originating source, but can emotionally enhance the message. The mood that audio evokes is an important factor in how a viewer reacts to a typographic message. Two sequence examples are identical except for the musical score applied—one attempts to place the viewer in a solemn, pondering state (084|056), while the other attempts to create excitement and energy (083|056).

Audio can be divided into four forms: music, speech, ambient sounds, and sound effects. Speech includes both narration and dialog. Ambient sounds are naturally occurring sounds such as traffic or the wind blowing.

082 | 056 Audio: literal, speech

083 | 056 Audio: abstract, music

084 | 056 Audio: abstract, music

085 | 057 Audio: literal, speech, sound effects, ambient sounds

086 | 057 Audio: literal, ambient sounds

Animation

Vivacity, passion, the state of being alive—these are some of the definitions *The Concise Oxford Dicitionary* attributes to animation. Less exciting but more precisely, animation is the stasis-to-motion technique of creating the illusion of movement through the recording of successive stills shown sequentially.

Persistence of Vision

Persistence of vision is a physiological phenomenon of perception which explains how we see motion through the animation of still images or words. Our mind's eye holds onto the images for a slightly longer duration than they are actually seen by the retina, so that a series of quick flashes is perceived as one continuous image.

The thaumatrope, a toy that was widely available in the nineteenth century, demonstrates persistence of vision. A disc is suspended between two strings and when spun, images placed on either side of the disc are perceived as one (Fig. 01). A flip-book, a series of images on individual pages, also demonstrates persistence of vision and is one of the earliest animation techniques. The lower left corner of *Moving Type* contains a flip-book, designed and produced by hand-stamping on paper with lead type and an ink pad.

It is because of persistence of vision that images sequentially projected (film) or displayed (monitor) with slight changes from image to image are perceived as one continuous motion. This is the perceptual foundation of all sequential media.

Fig. 01, Thaumotrope

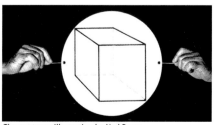

Thaumotrope Illustration by Ned Drew

Techniques

There are a number of techniques and materials used in traditional animation processes—cameraless, line and cell, stop-motion, and rotoscoping are a few. Cameraless animations, also known as scratch films, involve working directly onto the film celluloid, such as 16mm film clear leader or black leader. Clear leader allows the animator to draw directly onto the film, and the marks on the film block the light from the projector. Black leader, which has a black coating on the celluloid intended to block the light of the projector, can be scratched away to allow the light through, thereby creating *white* lines and marks when projected. In addition to literally scratching, black leader can be dissolved away with household bleach, colors applied, holes punched, and more—experimentation is recommended. Beautiful and extremely kinetic visual activity can be accomplished in cameraless animation when the frame lines of the film strip are ignored (040|043).

One of the most well-known but time-consuming methods of animation is line-and-cell animation. This technique involves working directly onto paper or transparent sheets of celluloid, frame by frame. Each individual drawing or cell is then photographed onto film or videotape, or digitally scanned (Fig. 02).

Stop-motion animation is also a frame-by-frame technique, but involves animating objects rather than drawings. Processes such as claymation and puppet animation are examples of the stop-motion technique. Objects are photographed onto film, videotape, or a computer (using video-capture software) frame by frame, making slight changes in the object's position after each exposure (Fig. 03).

Rotoscoping is a technique in which the image on each frame is traced or manipulated directly. Digital rotoscoping has made easier what was once a technique that involved complicated and expensive analog equipment (Fig. 04). All of these traditional analog techniques are still viable today, and many have become married to digital technology to reduce the time involved and ease the labor process.

Fig. 02, Line animation

Fig. 03, Stop-motion animation

Fig. 04, Digital rotoscoping animation

040 | 043 Cameraless animation by Evan White while a student at Wanganui Polytechnic School of Design, New Zealand.

Fig. 02, Line animation by David Grant while a student at Virginia Commonwealth University, USA.

Fig. 03, Stop-motion animation by David Grant while a student at Virginia Commonwealth University, USA.

Fig. 04, Digital rotoscoping animation by David Grant while a student at Virginia Commonwealth University, USA.

Fundamentals

Historically, animated films were hand-drawn and then photographed frame by frame onto film, and later, videotape. This technique is still in effect today, using digital technology to assist in the process, as opposed to animation that is completely digital, such as the Pixar Animations™ film *Toy Story*®. Producing an animation by hand is extraordinarily time-consuming—a two-minute animation at 24 frames per second would consist of 2880 individual drawings, one drawing for each frame (24 fps x 120 seconds=2880). Animators save time by duplicating individual drawings over a 2- or 3-frame duration. In other words, each drawing would be exposed onto film or video for 2 or 3 consecutive frames. This is known as the frame rate of the animation (working on 2s or 3s). If the 2880-frame animation was 'shot on 3s', then only 960 individual drawings would need to be completed. This is still extremely time-consuming, but less than it would have been otherwise.

Keyframes are the specific frames which designate the beginning and end of a movement or direction, opacity, scale, or other change in the nature of the activity. The frames which exist, or fill in, between keyframes are known as inbetweens. Digital animation software will complete an action by filling in the inbetweens once the keyframes have been designated.

The letter *a* is animated horizontally from the left side of the frame to the right; the action will occur over a period of 2 seconds. It is placed at the beginning position of the movement, at which point a keyframe is designated. Moving forward in the timeline 2 seconds, a second keyframe is designated. The software program will fill in the remaining positions of the letter across this path (Fig. 05). Multiple keyframes can exist in a sequence (041|044). Fig. 06 shows the timeline from Adobe After Effects™ for sequence 041|044—6 keyframes are represented for each change in position and direction.

Fig. 05 Keyframes

041 | 044 Multiple keyframes

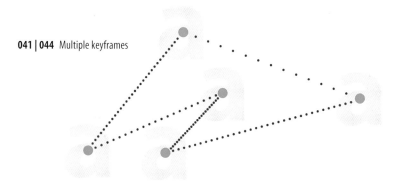

Fig. 06, Adobe After Effects™ time layout window

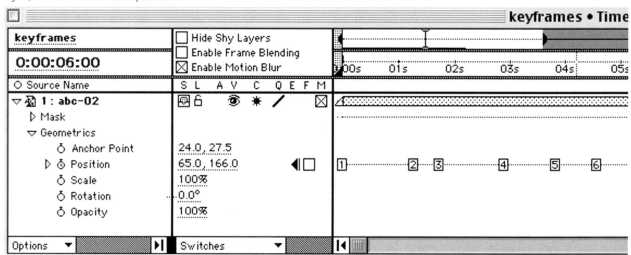

The steady transition from stasis to a constant speed is known as *easing in* and *easing out*. An automobile doesn't speed up or stop instantly, the change is gradual. Easing in and out adjusts the speed at the beginning and ending of a movement (the keyframes) to enhance the reality of the movement, create a particular effect, or allow a smoother motion for the path (042|045).

Both the duration and number of frames an action requires, and the distance a movement has to traverse in the frame, affect the speed and smoothness of animation. Assuming a constant distance, the greater the number of frames it takes to travel that distance, the longer the duration of the movement (slower and smoother). The fewer the number of frames the movement takes to travel that distance, the shorter the duration (faster, less smooth) (043|045).

Assuming a constant duration and number of frames, the greater the distance an object has to travel, the faster it will move. The shorter the distance an object has to travel, the slower it will move (044|045).

If a letterform was moving very rapidly vertically down the screen in a film, and we were able to capture that moment in a photograph, the resulting image would be blurred. This is because the pace is too fast for the film to differentiate between frames, so the perception in our brain is that they visually blur together. Digital animation programs possess a motion-blur filter which will add a directional blur appropriate to the actual direction, and enhance the reality of the speed and movement (Fig. 07).

042 | 045 Ease in/ease out

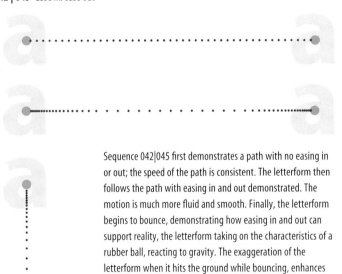

043 | 045 Constant distance

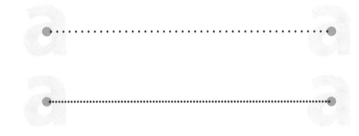

Sequence 042|045 first demonstrates a path with no easing in or out; the speed of the path is consistent. The letterform then follows the path with easing in and out demonstrated. The motion is much more fluid and smooth. Finally, the letterform begins to bounce, demonstrating how easing in and out can support reality, the letterform taking on the characteristics of a rubber ball, reacting to gravity. The exaggeration of the letterform when it hits the ground while bouncing, enhances the reality of the *bounce*.

044 | 045 Constant duration and number of frames

Based on 30 fps, sequence 043|045 travels a constant 316 pixels distance horizontally across the frame. The first attempt is set for a 45-frame duration, therefore the path is completed in 1.5 seconds. The second attempt is set for a 90-frame duration, therefore the path is completed in 3 seconds. Same distance, more frames, longer duration.

Sequence 044|045, also based on 30 fps, travels at a constant duration of 1.5 seconds. The first attempt is set for a distance of 316 pixels, therefore it takes 45 frames to complete the path. The second attempt is set for a distance of 162 pixels, half of the first distance, it still takes only 45 frames to complete the path, but appears to move more slowly. Same duration, less distance, slower movement.

Fig. 07

Kinetics

Kinetics

Kinetics is defined as actions or arrangements that produce, change, or imply the motion of objects. The ability to design for motion is the essence of typographic animation. In static typographic design, direction refers to the orientation of letterforms—including the way they are read—in a composition. Printed letters are conventionally arranged in words, and words into sentences, etc. on a horizontal baseline. The reading direction of these letters is also horizontal. Reading direction is left to right, from upper left to lower right of a single page. The letters are static, the reading eyes move. When we refer to direction in kinetic typography, we are also adding the literal definition of movement.

Orientation is the directional position of the baseline of the type. *Direction* is the course or line of the movement of the type. *Rotation* is movement around an anchor point, the center of the rotation. Direction and orientation can be horizontal, vertical, diagonal, circular, advancing, or receding. Direction, orientation, and rotation can either occur on the two-dimensional frame plane (the x and y axis), or spatially on the depth plane, advancing and receding (the z axis). Refer to the Cartesian coordinate system on page 21.

The determinates for hierarchy in print—small to large (scale), color, and position—are joined by the determinates of fast and slow and advancing and receding.

051 | 046 Direction: circular · Orientation: circular

045 | 046 Direction: horizontal · Orientation: horizontal

046 | 046 Direction: vertical · Orientation: horizontal

047 | 046 Direction: vertical · Orientation: vertical

052 | 046 Direction: advancing, receding

048 | 046 Direction: horizontal, vertical · Orientation: vertical

049 | 046 Direction: diagonal · Orientation: diagonal

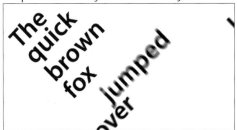

050 | 046 Direction: diagonal · Orientation: diagonal

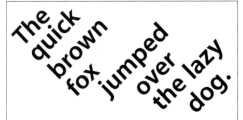

053 | 046 Direction: random

054 | 047 Rotation: flat, anchor point changes

055 | 047 Rotation: spatial, vertical, and horizontal axis

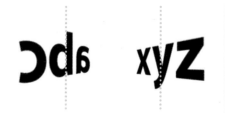

056 | 047 Rotation: spatial, vertical, and horizontal axis

057 | 047 Rotation: random

Direction
Orientation
Rotation
Proximity
Grouping
Layering

Unless one is a genius, it is best to aim at being intelligible.

Anthony Hope, *The Dolly Dialogues,* 1894

Proximity

Proximity is the distance between letters, words, and lines of type created by altering the kerning, tracking, and leading relationships in text. Time-proven, optically measured parameters for *good* proximity remain important for legibility of type, particularly moving type on the screen.

However, interesting visual relationships and enhancement of content can occur when kerning, letterspacing, and leading are all set into motion. The definition of a word or meaning of a phrase can be supported (058|048), or a discovery can occur (059|048).

Altering proximity can be very conducive to dialog when the designer is attempting to capture the voice and emotions of the words being spoken (see *Intonation,* page 33). For example, increasing letterspacing visually supports the idea of satisfaction.

| DELICIOUS |
| DELICIOUS |
| DELICIOUS |
| DELICIOUS |
| DELICIOUS |
| DELICIOUS |
| DELICIOUS |
| DELICIOUS |
| DELICIOUS |
| DELICIOUS |
| DELICIOUS |

058 | 048 Proximity: leading, tracking

059 | 048 Proximity: kerning

Sequential Proximity

Moving type requires another delineation called sequential proximity. Effective and appropriate sequential proximity ensures that the appearance of each word in the text appears in the exact, or a relatively close vicinity, of the word which preceded it (060|049, 061|049). The intent should be to allow the eye of the audience to follow a consistent path and create a visual flow.

Sequential proximity applies to both transitional and directional situations (064|049). The designer must bear in mind how his/her particular culture reads, and try not to alter that too much. The English language reads from left to right, and from top to bottom (063|049).

Words should not appear in random locations on the screen, as this makes it difficult for the eye of the audience to follow the text, causing disorientation and impairing legibility (062|049). The diagram to the right for sequence 062|049 shows the order in which the text appears from the first word through the last. This problem will increase as the physical size of the frame increases (film projection versus Internet Quicktime™ movies). It is possible to break away from strict directional proximity as long as the eye of the audience is allowed to follow a consistent path (065|049).

060 | 049 Sequential proximity: transition (flush left)
061 | 049 Sequential proximity: transition (centered)

062 | 049 Sequential proximity: transition (random)

063 | 049 Sequential proximity: transition and direction

064 | 049 Sequential proximity: direction

065 | 049 Sequential proximity: transition and direction

Kinetics

Direction
Orientation
Rotation
Proximity
Grouping
Layering

Do you wonder that I was late for the theater when I tell you that I saw two Egyptians As . . .walking off arm in arm with the unmistakable swagger of a music-hall comedy team? . . .after forty centuries of the necessarily static Alphabet, I saw what its members could do in the fourth dimension of Time, 'flux', movement.

Alphabet 1964: International Annual of Letterforms

Grouping

Related to proximity is the concept of grouping. Like proximity, grouping applies to both directional and transitional situations, but is concerned with the *balance*, symmetrical or asymmetrical, and *disposition* of the typography within the space of the frame.

Balance

A symmetrically composed frame consists of type that is divided into parts of an equal shape, size, and similar position to the point, line, or plane of division. Symmetry implies correct proportion, comfort, and visual harmony. Film or television credits that scroll or crawl at the end of a presentation are a good example of type symmetrically composed—and perfectly centered within the frame. Scrolls can be either directional (066|050) or transitional 067|050).

An asymmetrically composed frame derives its visual balance through the interaction of the type with the negative space surrounding it. Asymmetry creates a visual tension which is desirable because it is often more interesting. Both directional and transitional sequences are shown here (068|050, 069|050).

066 | 050 Grouping: symmetrical balance (direction)

> Do you wonder
> that I was late
> for the theater
> when I tell you
> that I saw two
> Egyptians A's . . .

> walking off
> arm in arm
> with the
> unmistakable
> swagger of
> a music-hall
> comedy team?

> could do in
> the fourth
> dimension
> of Time,
> 'flux',
> movement.

067 | 050 Grouping: symmetrical balance (transition)

> Egyptians A's . . .
> **walking off**
> arm in arm
> with the
> unmistakable

> swagger of
> a music-hall
> comedy team?
> **. . . after forty**
> centuries of

> static Alphabet,
> I saw what
> **its members**

068 | 050 Grouping: asymmetrical balance (direction)

> for the theater
> when I tell you
> that I saw two
> Egyptians A's . . .
> walking off

> . . . after forty
> centuries of
> the necessarily
> static Alphabet,
> I saw what its members co

> n of Time, 'flux', movement.

069 | 050 Grouping: asymmetrical balance (transition)

> Do you wonder
> that I was late
> for the theater
> when I tell you
> **that I saw two Egyptians A's . . .**

> . . . after forty
> centuries of
> the necessarily
> **static Alphabet,**

> I saw what
> its members
> could do in
> the fourth
> dimension
> **of Time, 'flux', movement.**

Curiosity is one of the permanent and certain characteristics of a vigorous intellect.

Samuel Johnson, *The Rambler*, 1750–2

Disposition

In filmic terms, an *open frame* is one in which activity takes place outside the frame and the view of the audience. A *closed frame* is one in which all of the activity is within the frame and view of the audience.

In typography we refer to this as *disposition*—the arrangement of letters and words to each other and the edge of the frame. The disposition of a typographical sequence is therefore either dissonant or consonant.

Consonance implies contraction and occurs when the disposition of type is tightly arranged, or all the movement occurs within the frame (070|051). *Dissonance* implies expansion and occurs when the activity of the type breaks the boundaries of the frame (071|051).

Particular to moving type is the ability to alter the disposition over time. Type entering from outside the frame in dissonant arrangement can manoeuvre itself into a consonant composition (072|051) and vice versa (073|051).

Consonance

Dissonance

Consonance to Dissonance

070 | 051 Grouping: disposition (consonance)

071 | 051 Grouping: disposition (dissonance)

072 | 051 Grouping: disposition (dissonance to consonance)

073 | 051 Grouping: disposition (consonance to dissonance)

Layering

Three different types of layering can be achieved creating different levels of opacity: opaque, translucent, or transparent. Varying levels of opacity can aid in determining visual layering from top to bottom, or front to back.

Opaque refers to the state of complete opacity when, in layered letters, words, and shapes, the uppermost layer completely covers and blocks the layers below. When working with simple color or positive-negative palette combinations, a type of revealing can occur (074|052, 076|052).

A translucent state of opacity is achieved when some light is allowed to pass through. There are varying values of translucency, and when multiple translucent words and letters are layered, a type of ghosting optical effect can occur, resulting in intriguing letterform combinations (075|052). When colors are translucent and overlap, they mix in real time (076|052).

Transparent is that state of opacity in which layered elements appear hollow. Outlined letterforms and letterforms punched out of solid shapes allow layers to be completely seen (076|052).

074 | 052 Opacity: opaque

075 | 052 Opacity: translucent

076 | 052 Opacity: opaque, translucent, transparent

077 | 053 Opacity: translucent, transparent

Opacity can also be effective over continuous tone imagery: in this case, an out-of-focus video of colorful lights functions as a background in which translucent and transparent letterforms allow the light to diffuse through at varying levels (077|053).

Moving colored rectangles overlap to reveal letterforms beneath, their state of translucency mixing live to create a multitude of color combinations (078|053).

The concept of tonality (closely related to opacity but not to be confused with it) refers to screen or tint of color, but still in an opaque state. It refers to the general lightness or darkness of the hue (see page 30).

078 | 053 Opacity: translucent

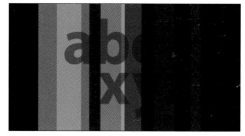

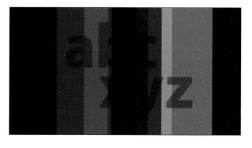

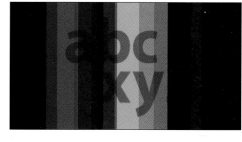

Sequence Structure

Structure is the physical arrangement and appearance of a sequence—how the content is organized and presented. Typically film, video, and Quicktime™ sequences have a linear structure; they have a definite beginning, middle, and end (Fig. 01). Linear implies a unilateral direction toward a predetermined message. Interactive hypermedia experiences, such as websites, possess a non-linear structure and multi-linear content delivery (linearity is multiplied and simultaneous). These structures allow navigational choices and random access by the audience, thereby altering possible interpretations in the message or narrative structure (Fig. 02).

There are essential differences in moving typography that are present in linear and non-linear structures. In broadcast television, which is linear, the pace of editing is often quick, the type duration is short, and functions more as image. The type is meant to be seen, not read (with the exception of credits, which are rarely read). Broadcast typography is presented in a predetermined voice, with the intention of leaving an impression.

The typography in film title sequences, also linear, has a particular purpose—to give credit to those involved in the making of the film. The choices involve typeface and editing and image, and the intent is to set an expectant mood for the film to follow. Whether the credits are actually read or not often seems unimportant.

The emphasis in interactive typography is more on the structure, which is non-linear. Navigation and audience participation allow for text to be read and contemplated, more like a book. The structure exists in potential, to be defined by the audience, who share control of the spatial structure of the work.

Even when linear sequences appear in digital media, they can often be viewed repeatedly on the computer itself, which gives them a different life than on television or film. Broadcast type is repeated somewhat randomly over a much longer period of time, with no viewer control over when sequences will play, and film title sequences require a return to the theater or video-rental store.

Dynamic Juxtaposition

To juxtapose visual elements, imagery, and typography, is to place them side by side. Within the context of a linear sequence, *dynamic* juxtaposition can occur. Type can be layered, occur sequentially, or appear simultaneously with image and other type elements. And because of the dynamic nature of the sequence, the juxtapositions are in flux and often unstable.

When type and image are layered, the type is visually integrated within the image, often resulting in the type functioning as image. Layered juxtaposition also occurs when the type overlaps the image, but is not necessarily integrated within it (079|055).

When type and image are sequentially juxtaposed, they do not appear within the frame at the same time, but instead appear alternately or successively. Sequential juxtaposition relies on memory, because the viewer is making relationships between the elements as they occur (080|055).

Simultaneous juxtaposition occurs when type and image appear at the same time within the frame and are visually separated, but not layered. Most commonly simultaneous juxtaposition includes the creation of *zones* of information (081|055). These three categories of dynamic juxtaposition are not exclusive—a sequence can be defined within the parameters of one, two, or all three categories.

Fig. 01, Linear structure diagram

Fig. 02, Non-linear structure diagram

079 | 055 Dynamic juxtaposition: layered

080 | 055 Dynamic juxtaposition: sequential

We receive three educations, one from our parents, one from our schoolmasters, and one from the world. The third contradicts all that the first two teach us.

Baron Charles de Montesquieu, eighteenth century

083 | 056 Hierarchy: type dominant
084 | 056 Hierarchy: type dominant

Hierarchy

An important component of sequence structure is hierarchy. This is not in reference to visual hierarchy, demonstrated throughout the book in regards to typographic and formal characteristics, spatial relationships, and kinetics. *Structural* hierarchy is specific to the three components of a sequence (when two or all three are present)—type, image, and audio—and determines how a message is disseminated.

Sequential structure can be *type, image* or *audio dominant*. The dominant element is the main carrier of the message. The other two elements play a supportive role, and while they enhance meaning, they are not critical components in the understanding of the message (082|056, 083|056, 084|056, 086|57).

A synthesis of hierarchy between type, image, and audio can, and most often does, occur (085|057). A *parallel* synthesis occurs when all three components are of relatively equal importance, but removing one of them will not affect the message's intent. An *integrated* synthesis occurs when all three components are critical and must be present. Removing any one of them will drastically affect, or cause a collapse, in the communication.

082 | 056 Hierarchy: audio dominant

My fate cannot be mastered; it can only be collaborated with and thereby, to some extent, directed. Nor am I the captain of my soul; I am only its noisiest passenger.

Aldous Huxley, *Adonis and the Alphabet*, 1956

Nature, to be commanded, must be obeyed.

Sir Francis Bacon, *Novum Organum*, 1620

086 | 057 Hierarchy: image dominant

085 | 057 Hierarchy: synthesis

Sequence

Transition

In narrative sequences, transitions are used to emphasize the passing of time. In early films radial wipes, which mimic the movement of clock hands, implied time had passed as the film transitioned from one scene to the next, fades to black signaled the *end* of a particular moment, and dissolves from one scene to the next functioned as a comfortable formal device.

Transitions are beneficial to moving type because they are inherently dynamic. They are good formal devices, because it is often difficult to tell words apart visually, particularly if they are the same color, typeface, and size. A transition signals to the viewer that the word or phrase is changing. Common transitions include cuts, fades, dissolves, and wipes. Specialty transitions utilize otherwise normal effects as formal transition devices. Words fading in and out are also easier on the eye of the viewer/reader (087|058).

Unfortunately, many software programs offer numerous transition effects which are silly or otherwise unnecessary and pure visual *candy*. These should be avoided, as they can interfere with the content.

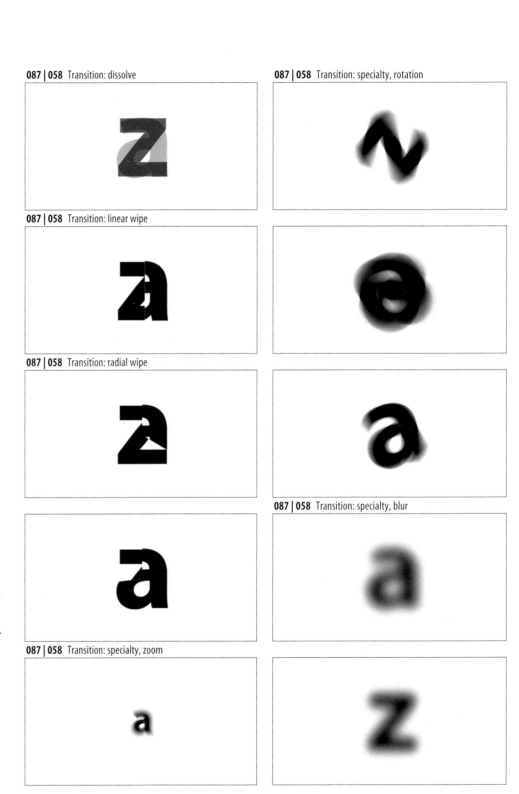

087 | 058 Transition: dissolve

087 | 058 Transition: specialty, rotation

087 | 058 Transition: linear wipe

087 | 058 Transition: radial wipe

087 | 058 Transition: specialty, blur

087 | 058 Transition: specialty, zoom

Transitions *can* emphasize content. Quick-cut edits support the concept of speed and energy, and can aid in the building of a climax. A word with a slow-fade transition applied to it is to be contemplated.

Transitions can also function as support in the reading of the text. The use of different transitions with the same overall concept in a type sequence is demonstrated in this aphorism: cut, fade, dissolve, wipe, blur, zoom.

091 | 059 Transition: linear wipe

Unless we *see* our subject, how shall we know how to place or prize it, in our **imagination** ?

Unless we *see* our subject, how shall we know how to place or prize it, in our **imaffections** ?

093 | 059 Transition: specialty, zoom

Unless we *see* our subject, how shall we know how to place or prize it, in our **understanding** ?

Unless we *see* our subject, how shall we know how to place or prize it, in our imagination ?

088 | 059 Transition: cut
089 | 059 Transition: fade
090 | 059 Transition: dissolve

Unless we *see* our subject, how shall we know how to place or prize it, in our **imagination** ?

Unless we *see* our subject, how shall we know how to place or prize it, in our **affections** ?

Unless we *see* our subject, how shall we know how to place or prize it, in our **imagination** ?

Unless we *see* our subject, how shall we know how to place or prize it, in our **affections** ?

092 | 059 Transition: specialty, blur

Unless we *see* our subject, how shall we know how to place or prize it, in our **understanding** ?

Unless we *see* our subject, how shall we know how to place or prize it, in our ？

Unless we *see* our subject, how shall we know how to place or prize it, in our **affections** ?

Unless we *see* our subject, how shall we know how to place or prize it, in our **imagination** ?

Rhythm and Pace

Rhythm is an action that recurs regularly, and pace is the rate of that rhythm. There are several ways to design with successful rhythm and pace, including creating visual rhythmic beats, contrasts in the pace of editing and movement, and paying close attention to the rhythmic relationships between type, image, and audio.

A visual rhythmic beat occurs when repetition of a word, or a sequence of words, happens in a consistant manner. The viewer becomes accustomed to this visual repetition.

Repetition of a word or phrase can also be a device for emphasis or hierarchy (see **Foreshadow and Recall**, page 62) and allows for a shorter duration, because the repetition of the word or phrase makes up for the time factor.

In addition to striving for an overall, comfortable rhythm and pace of the sequence, a designer can create contrasts in the pace of editing (duration) and movement between elements within the sequence. Type moves at different speeds, one blurringly fast in the background creating a type of visual texture, the other elements moving somewhat more slowly in the foreground. The contrast between them emphasizes the pace of all the elements (094|060).

Earlier, the concepts of scale and tonality were mentioned as factors in establishing depth: type close to the viewer and the edge of the frame is larger and darker, while type that is farther away is smaller and lighter. Pace adds to these factors, because type that is closer also moves past the frame much faster, while type that is farther away moves more slowly (095|060). This occurs because large type closer to the edges of the frame has a shorter distance to travel to cover the span of it, while type in the distance has a much farther distance to travel.

094 | 060 Rhythm and pace

095 | 060 Rhythm and pace

096 | 060 Rhythm and pace, no audio

097 | 060 Rhythm and pace, beat one
098 | 060 Rhythm and pace, beat two
099 | 060 Rhythm and pace, beat three

Structural Relationships of Type and Image to Audio

The relationship of the rhythm and pace of the visual elements (type and image) to that of the audio track in editing is categorized as *parallel*, *irregular*, or *counterpoint*.

In parallel structures the rhythm and pace of the visual elements is edited in perfect timing with that of the audio. In irregular structures, the rhythm and pace of the visual elements is uneven or inconsistent, while the audio is regular, and often prominent.

This relationship can also be reversed. In counterpoint structures, visual elements with a slow rhythm and pace are edited in counterpoint to a fast rhythm and pace of the audio track. These structural relationships between type, image, and audio are not exclusive—a sequence could theoretically contain any or all of them.

The diagram (below right) of sequence 097|060 demonstrates its type-to-audio structural relationships. Track 01 is consistent to the rhythm and pace of the audio, but progressively increases its pace. Track 02 is consistent and fast-paced throughout. Track 03 appears on every fourth beat; it is consistent but acts in counterpoint to the other tracks. Track 04 also acts in counterpoint to the other tracks, creating a consistently paced visual beat. Track 05 represents the audio component in visual wave form.

Sequences 097|060, 098|060, and 099|060 are visually identical, but the audio track is not. Each audio track has a different rhythm, but shares the same pace. Therefore the rhythm and pace of the typographical elements is always even to the audio. Even when viewing without audio (096|060), the rhythm and pace is detectable.

In audio, amplitude is the intensity or loudness of a sound. Typographic scale, weight, and tonality/opacity can create a visual relationship to the amplitude of the audio.

When making editing choices that determine rhythm and pace, remember that an overly consistent style can be predictable and monotonous. To avoid this, contrast in the pace of the editing should be introduced.

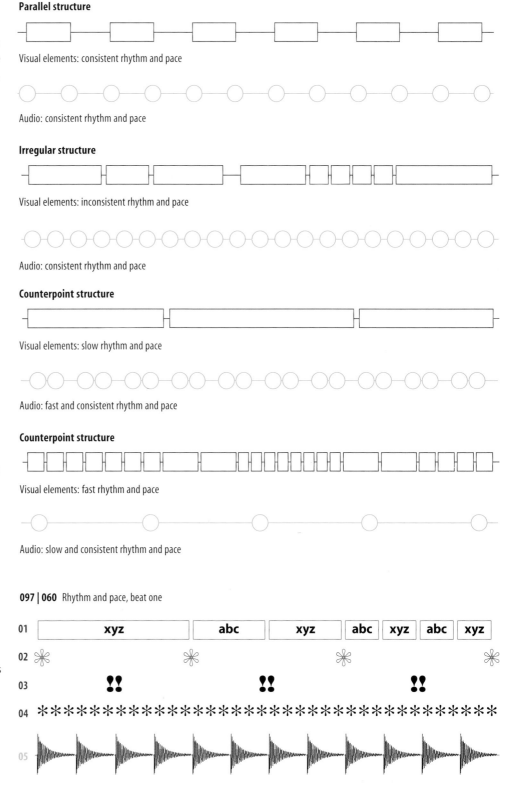

Parallel structure

Visual elements: consistent rhythm and pace

Audio: consistent rhythm and pace

Irregular structure

Visual elements: inconsistent rhythm and pace

Audio: consistent rhythm and pace

Counterpoint structure

Visual elements: slow rhythm and pace

Audio: fast and consistent rhythm and pace

Counterpoint structure

Visual elements: fast rhythm and pace

Audio: slow and consistent rhythm and pace

097 | 060 Rhythm and pace, beat one

01 xyz abc xyz abc xyz abc xyz

02

03

04

05

Structure

Juxtaposition

Hierarchy

Transition

Rhythm and Pace

Duration and Pause

Foreshadow and Recall

I and me. I feel me—that makes two objects. Our false philosophy is embodied in the language as a whole: one might say that we can't reason without reasoning wrong.

Georg Christoph Lichtenberg, *Aphorisms,* 1764–99

100 | 062 Duration and pause, foreshadow and recall

I and **me**

I feel **me**

two/o

that
makes
twotwo
objects

that
makes
two two
objects

Duration and Pause

Duration refers to the length of time a word or phrase appears and remains within the frame, moving or static, while pause refers to the length of time between the appearance of a word or phrase. Duration and pause are in direct correlation to the established rhythm and pace of the sequence.

Duration not only determines legibility by allowing enough time for reading to occur, but can also be a method to punctuate meaning and establish hierarchy. Pause allows time for the viewer to ponder what was just presented before the next event occurs; a visual rest stop. It can also be used as a device to create anticipation—what will occur next?

However, duration and pause that exceeds necessity can be laborious for the reader/viewer, and too short a duration hinders readability and causes disorientation.

Foreshadow and Recall

Moving type is ephemeral, the experience is fleeting. Nothing is left when it is over except an impression. Foreshadowing is to warn or indicate a future occurrence or event. Foreshadowing a word or phrase creates a question situation, then is later recalled (in normal sequence) to answer the foreshadow. Recalling or repeating a word or phrase reminds the viewer of what has already past.

our
philosophy is

our **false**
philosophy
is

one might say

E M B O D I E D

E M B O D I E D
in the language

that we can't **reason**

E M B O D I E D
as a **whole**

reason**ing**

In sequence 100|062, duration and pause are used as devices where words of the aphorism are repeated. *I* and *me* stay in the frame while *and* and *feel* appear sequentially to complete the phrases *I and me. I feel me.* This method is also utilized with the phrase *embodied in the language, as a whole*—the word *embodied* remaining, and again with the word *reason*, which later transitions into *reasoning.*

Foreshadow and recall are employed, with the word *two* appearing before the complete phrase *that makes two objects,* and then recalling itself, thus enhancing the concept of two by appearing twice. And again, less successfully, when the phrase *our philosophy is* appears before *false*, although the complete phrase correctly reads *our false philosophy is.* The idea is to emphasize the word *false* by introducing it later.

without
reasoning

without
reasoning
wrong

Pre-production

Pre-production involves the planning stages of designing a sequence before actual animation. This stage is essential due to the time-intensive nature of animation. It is during the pre-production stage of the design process that potential conflicts can be resolved, basic visual decisions made, and client approval on the concept at hand given. Three methods for pre-production planning are demonstrated: using notation symbols to score a sequence, traditional image-based storyboards, and text-only storyboards.

Scoring

When a sequence does not include images, or at least is mainly composed of type, a traditional image-based storyboard may not be appropriate. Notation symbols can be used in conjunction with a scoring template to *score* the sequence. Time code indicates duration, the notation symbols indicate direction and transitions. A note section exists for such information as typeface, size, color, specialty characteristics that are hard to sketch (like a blur), and audio information. The width and height of the frame in the template should reflect the actual frame aspect ratio.

00:00:00:00

frame/sketch zone

typeface
typesize
colors
other notes

audio notes

Fig. 01, opposite page, demonstrates using notation symbols to score a sequence. An alternative to showing only the time code as an indicator of duration would be to extend the width of the frame in relationship to the other frames, to show duration in a more concrete visual manner (Fig. 02).

Notation symbols for scoring a sequence

Linear direction, flat Linear direction, spatial

Random direction, flat Random direction, spatial

Rotation, flat Rotation, spatial

Transition, fade Transition, dissolve

Fig. 02

$X \quad Z \quad \bar{X}$

Fig. 01, Scoring with notation symbols

00 : 00 : 01 : 00

Myriad 700, 10 pt, blue:
letterforms begin to randomly appear and multiply.

Begin typewriter audio.

00 : 00 : 05 : 00

Letterforms continue to appear and multiply, and begin to move in a random, flat pattern, exiting frame upper left.

Typewriter audio continues, pace quickens.

00 : 00 : 12 : 00

Letterforms stop multiplying, but continue exiting frame upper left.

Bodoni Bold 'a', 48 pt, black:
fade in 1 second, hold 4 seconds.

Typewriter audio begins to fade out.

00 : 00 : 18 : 00

Fade out 'a' 1 second.

Bodoni Bold 'b', 48 pt, red:
fade in 1 second, hold 6 seconds.

Begin jazz audio, fade in, keep levels low.

00 : 00 : 26 : 00

Fade out 'b' 1 second.

Bodoni Bold 'c', 48 pt, green:
fade in 1 second, hold 8 seconds.

Myriad 700 Caps 'A', 0–72 pt, black:
0% to 100% opacity, exit frame lower left,
2 seconds.

00 : 01 : 05 : 00

Fade out 'c' 1 second.

Myriad 700 Caps 'B', 0–96 pt, red:
0% to 100% opacity, exit frame left,
2 seconds.

00 : 01 : 07 : 00

Myriad 700 Caps 'C', 0–96 pt, green:
0% to 100% opacity, rotate 4 revolutions, exit frame upper left, 3 seconds.

Bodoni Italic 48 pt, black 'a': 1 second stagger, hold 3 seconds.

00 : 01 : 14 : 00

'a' dissolves into 'b', 3 seconds.
Hold 'b' 3 seconds.

Bodoni 'abc', 18 pt, red: enters frame top, fades out as it exits frame bottom, 3 seconds.

00 : 01 : 20 : 00

'b' dissolves into 'c', 3 seconds.
Hold 'c' 3 seconds.

Myriad 700 'a', 0–60 pt, green: random path to frame center, 5 seconds. Hold 3 seconds. Fade out, 1 second.

Fade audio out.

Traditional Image-based Storyboarding

The example here, a storyboard designed by Sonya Mead and Margaret Jacobi for the iomega™ ditto® interactive installation animation that came with the disk, consists of three distinct stages leading up to implementation and animation.

Stage one is a rough sketch done initially on notepaper. It demonstrates the designers working on initial ideas towards a final concept. These rough sketches are the designers' notes only, and would make less sense to someone else. The width of the frames in this sketch vary to indicate a sense of structure and duration (Fig. 03).

Fig. 03

Fig. 04

which on green-icon /easy words /green-verah on the right

which on red icon / quick words appear / red-verah on the left

Fig. 05

Stage two consists of *look-and-feel* boards: more detailed sketches that give the client an idea of tone and style. They introduce color, images, typeface, frame aspect ratio, and basic navigation devices (Figs. 04, 05).

Stage three is the storyboarding stage. This storyboard, fairly detailed sketches in color, gives the client an idea of the concept of the animation as a whole (Fig. 06). The storyboard combines computer typesetting and hand sketches. The final sequence (101|067) shares elements that exist in the storyboard, but more importantly, the storyboard gives the designers a point of departure.

101 | 067 iomega™ ditto®

iomega™ ditto® animation

Sonya Mead and Margaret Jacobi, designers
Peter Newbury, programmer
Gideon Ansell, music

Fig. 06

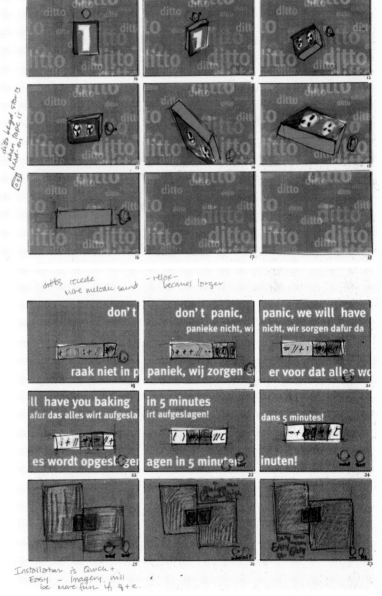

images

tightrope walker	venetian blinds	feather	jockey	conductor	violin
popovers	paper edge	flying squirrel	balloon	TGV	waterfall
CD	rings of Saturn	hummingbird	glider	Concorde plane	fast food
saber	snake	clouds	spider	bullet & apple	gymnast in iron
foil	contact lens	waterbug	1% milk	Contrail	train sign
epee	balance beam	Calder mobile	bungee jumper	bat hitting ball	chameleon
train tracks	laser	popovers	diver	tugboat	railroad light
crack of dawn	east wing	Brooklyn Bridge	spider web	pulley	block & tackle
flatiron building	scull	butterfly		rollerblading	chess piece
slice of sushi	eclipse			historical leaders	propeller
corona				wave	

text

1.1	wafer-thin	4	freedom	1.33	stealth
skinny	svelte	weightless	freestyle	empower	prowess
hairline	horizon	agile	sleek	finesse	catalyst
				connect	

rough video everyday *rough video everyday* *rough video everyday*
juxtaposed with clean images *juxtaposed with clean images* *juxtaposed with clean images*

THIN	LIGHT	POWERFUL/FAST	DIGITAL LOGO
SCREEN ATTRIBUTES a thin band which displays the images, dominant blue palette with others	**SCREEN ATTRIBUTES** the images float on the screen, dominant yellow palette	**SCREEN ATTRIBUTES** all images are in motion, dominant red palette	**LOGO RESOLVE** slabs of burgundy, changing color and typefaces
PRODUCT FEATURE VIDEO crack of colored light through door falls across the notebook	**PRODUCT FEATURE VIDEO** wind-up jumping chick upsetting the notebook or frisbee notebook	**PRODUCT FEATURE VIDEO** flyover of textural landscape of laptop opened, over spinning cd, past luminous speaker, mountainous keys	

STARTING POINT collage of fast-paced actions, escalators, commuter trains, train signs changing, flights departing and arriving, soccer game

connectivity

multimedia

international

motion

music direction

STYLE 01: clean, easy, rock, international

STYLE 02: chorally, lots of airy voices

STYLE 03: techno

music pad	music pad	music pad

Fig. 07
Diagrammatic storyboard
Original has been altered to
a vertical format, and color
has been added.

Text diagrammatic Storyboard

A complicated, detailed sequence structure is sometimes most successfully planned out and demonstrated to the client using a text-diagrammatic storyboard (Fig. 07). Created by Sonya Mead, this storyboard is for a 90-second animation which shows the capabilities of the Digital™ Hi Note laptop computer. It is divided into three sections that are each 30 seconds in length, and parallel the three factors of the computer the client wanted to demonstrate: thin, light, and powerful.

In addition to showing the structure of the animation to the client, this diagrammatic storyboard facilitates the important step of approval by the client, including the approval of imagery and text. This particular animation was designed in six different languages, so the text needed to be approved before the translation process could begin. The diagrammatic storyboard also indicates the sound and rhythm of the animation. Sequence 102|069 demonstrates the final result.

102 | 069 Digital™ Hi Note

Digital™ Hi Note animation

Sonya Mead, designer
Seth Magnum, programmer
Gideon Ansell, music

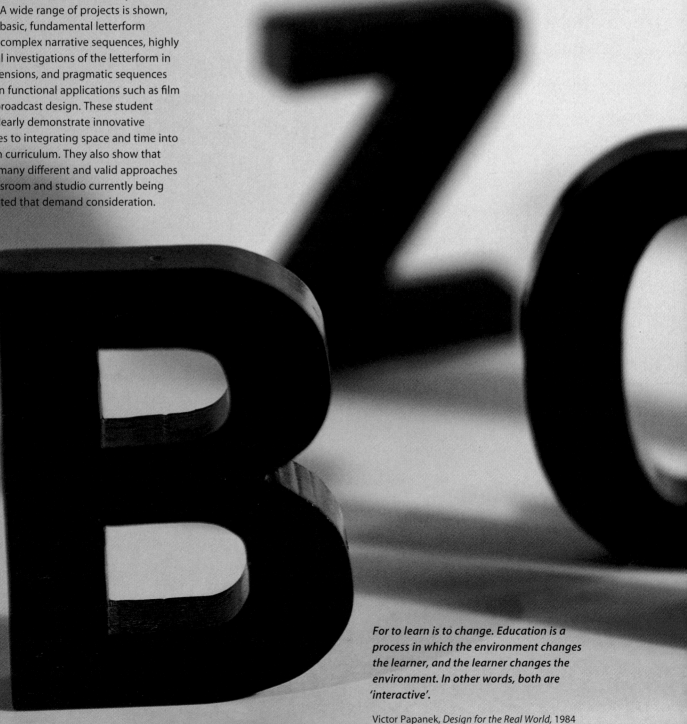

Design Education

Highlighted in *Design Education* are student projects from seven design programs throughout the USA: The Art Institute of Boston at Lesley College, California College of Arts and Crafts, California Institute of the Arts (CalArts), University of Connecticut, Parsons School of Design in New York City, Ringling School of Art and Design in Florida, and University of Texas at Austin. A wide range of projects is shown, including basic, fundamental letterform exercises, complex narrative sequences, highly theoretical investigations of the letterform in three dimensions, and pragmatic sequences focused on functional applications such as film title and broadcast design. These student projects clearly demonstrate innovative approaches to integrating space and time into the design curriculum. They also show that there are many different and valid approaches in the classroom and studio currently being implemented that demand consideration.

What is design education doing to prepare a generation of design students who have grown up in the most visually-oriented society in history? Students entering university today are media-savvy. . . spending weeks painting letterforms with a brush on mat board is no longer appropriate. The democratization of desktop digital technologies certainly has increased the opportunity for designers to work not only in film and television but also new media. But motion-based and interactive communication require more—the traditional design curriculum combined with software skills is not sufficient. How design curriculums will *integrate* typography and design, interactivity, time, and motion, is paramount.

An appropriate curriculum would include the study of film processes and editing theories. Narrative structures of storytelling and sequencing are vital. An understanding of both traditional and digital animation processes is crucial. The awareness of audio principles, and the important role sound plays in a successful and creative sequence, is important. These new components must certainly combine with a solid foundation in typography and design and a well-rounded liberal arts education.

For to learn is to change. Education is a process in which the environment changes the learner, and the learner changes the environment. In other words, both are 'interactive'.

Victor Papanek, *Design for the Real World,* 1984

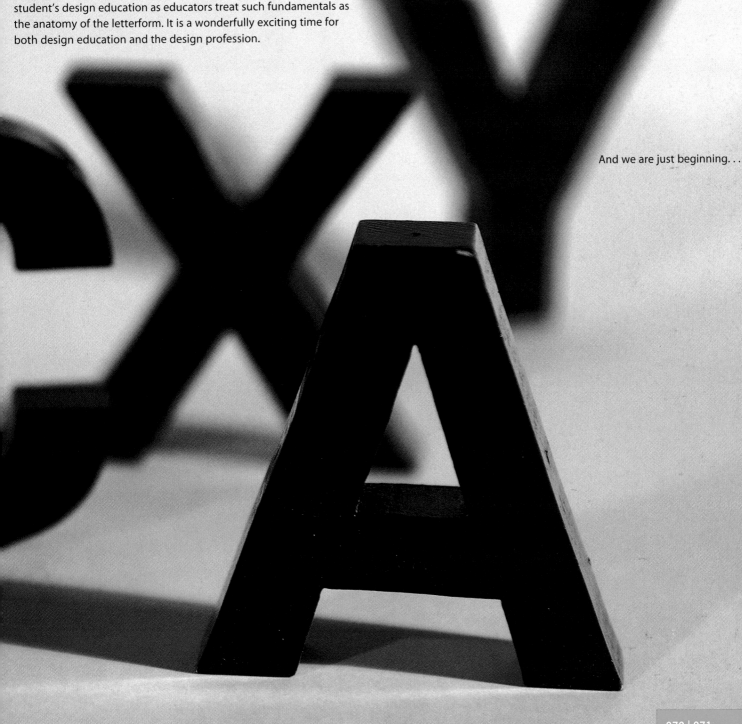

Walter Herdeg, in *Film & Television Graphics 2: An International Survey of the Art of Film Animation* (1976), wrote:

> *Both film and television [new media] are still at an early stage of development and need designers in the same way as a good building needs the skill of an architect. And just as an architect affects, through his design, the actual life of individuals, so graphic design has a much wider influence than its immediate object. As an opinion maker, a salesman, an educator, an entertainer, a humorist, an experimenter and a scientist, the graphic artist can fulfil, even if indirectly, one of the most basic communicative functions of the present day. He can also be among the first to influence the constant changes in these restless and dynamic media, where the evolution of styles and techniques demands analyses of cinematographic phenomena and a deeper understanding of psychology and human behaviour. Mental alertness, ideas and high creativity are essential here.*

Typography and design in motion is an exciting multidisciplinary and collaborative discipline that integrates a desire to combine various media with our natural humanistic tendencies towards movement. It has taken many years for typographic education to develop—so too will this. One thing is certain: the integration of space and time must occur early in a student's design education. It must not be treated as a separate course—an elective made available only after the other curriculum requirements have been met. It is not just for *advanced* study, but should be considered as vital and integral a part of the student's design education as educators treat such fundamentals as the anatomy of the letterform. It is a wonderfully exciting time for both design education and the design profession.

And we are just beginning. . .

Jeff Bellantoni

Instructor

Carla Imperati
Kate Kenny
Daniel Ben-Kiki
Christian Kubek
Lisa Milazzo
Carissa Rutkauskas

Designers

Word Opposites · Word Transitions

One of the most difficult dilemmas facing a motion typography and design course is the learning curve of the software. Does the instructor expect the students to learn it on their own? Does the course allow time for the students to learn the software before entering into concept-based projects? Is a parallel approach more effective, learning the software while working through fundamentals and concepts? *Word Opposites · Word Transitions*, a project taught in the Motion Typography and Design course at the University of Connecticut, takes a parallel approach, conceived in the spirit of the student learning the software and just beginning to conceptualize letterforms in time and space.

The students choose two words with opposite meanings, and then design and produce a 20-second sequence which demonstrates a *transition* from one word to another. When first working with animated type the student often tries to do too much too soon, so a step-by-step approach is effective, and setting a time limit on the sequences initially gives them some discipline over their concept. The color palette is limited to two solid colors, and no photography or illustrative imagery is allowed, in order to focus on the letterforms of the two words. Support factors such as ruled lines, shapes, and fragmented letterforms are encouraged.

Vertical bars cover the word *oppression*. Horizontal bars move in to turn the incarcerated word into its opposite: *freedom*, eventually breaking out and forcing the letters of *oppression* out of the frame (103|072).

The opposition of *strong* and *weak* is reinforced in this sequence through scale, position, and movement. Further enhancement of this wonderfully effective opposition comes through the appropriate choice of musical score (104|073).

Horizontal lines mimicking window blinds open to reveal the word *day*, which is slowly eliminated by *night* through layering the repeated word until darkness has completely overcome (105|073).

Up and *down* are the two word opposites in this wonderfully choreographed sequence, intentionally set in a vertical aspect ratio to support the concept. Support elements consisting of ruled lines and symbols join in the dance (106|073).

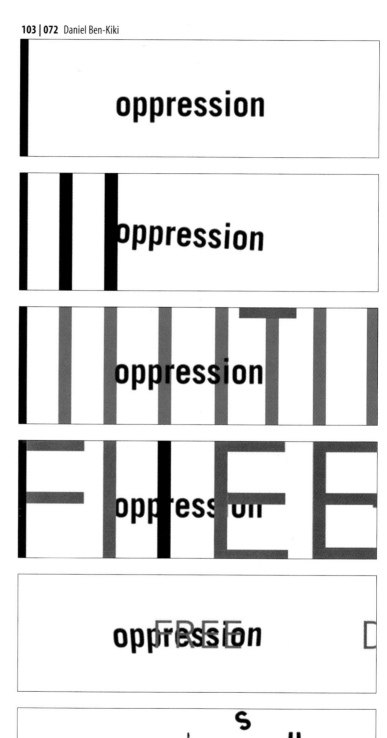

weak

night

STRONG

STRONG

up

up

down

up

down

up

down

A multitude of typefaces in varying scale, position, and rotation represent *chaos*. Layering of the letterforms creates a black screen, then the word *order* is introduced in a simple direct manner in the most geometric of all typefaces, Futura. The emphasis on contrast is quite apparent in this sequence (107|074).

The word *wet* drops like water, circles expand like ripples of waves, all of which is reinforced by the sound of water drops. All the while the word *dry* attempts desperately to transition in, but is consistently overcome by *wet* (108|074).

Design Education

University of Connecticut

Jeff Bellantoni

Instructor

Carla Imperati
Kate Kenny
Phuanh Tran

Designers

Type · Image Sequence

This project follows the introduction of the fundamentals of *sequence* (see pages 054–059). Kinetic movement of the type is not introduced in this project, so the focus is on the structure of the sequence (the order in which type and image are introduced). Photographic and illustrative imagery can be introduced, but only as a sequence of stills.

The content of the type-image sequence is derived from an article, such as a magazine or newspaper article, although text derived from personal writing is allowed. The inclusion of audio is encouraged, and a one-minute time limit is placed on the sequence. Editing of the text is discouraged, but repetition and other similar forms of emphasis and intonation are encouraged.

When introducing this project, the theories of *montage* are discussed with the students. V.I. Pudovkin and Sergei Eisenstein were two Russian film-makers and theorists who, in the 1920s, theorized about montage, or the juxtaposition of images within a linear sequence structure. Pudovkin thought that new meanings could be created through the juxtaposition of shots, insisting that the meanings lie in the juxtaposition of the shots, not in the shot alone, and that montage should function as *linkage* in the narrative.

In opposition to Pudovkin's theory, Eisenstein theorized montage as *collision* rather than linkage. Montage was about the creation of ideas, a new reality, rather than support of narrative. In Eisenstein's theory of montage, two shots worked together to create a third, new meaning. The audience is an equal participant in the process, working to understand the inherent meaning of the sequence.

109 | 075 Carla Imperati

David Mamet, playwright and film-maker, says that the juxtaposition of two unrelated images in a sequence to create a third, new meaning works because the nature of human perception is to perceive two events, determine a progression, and discover what occurs next. The human mind, according to Mamet, would make sense of the juxtaposition regardless of how random or unrelated it was.

An article about a tragic event is the content for this sequence, which relies on reversed images and shadow silhouettes. The typeface Courier is similar to that of a typewriter, enforcing the idea of a news article. The rhythm and pace of the sequence allows the type to be contemplated, and supports the overall mood of the tragic event that is supposed to have occurred (109|075).

110 | 076 Phuanh Tran

111 | 076 Kate Kenny

Sequence 110|076 derives its content from a personal account of the bombing of Hiroshima. A clock in the upper right of the frame gives the viewer the time of the incident, and effective mechanism to communicate the sudden nature of the attack. A minimal use of imagery is an appropriate decision.

Sequence 111|076 uses an article which describes the death of the designer's grandfather, allowing a personal connection to the content. This sequence uses a gradual increase in the pace of the editing most effectively, building anticipation as the events of the incident are revealed to the audience.

Jeff Bellantoni

Instructor

Georgina Montana
Christian Kubek

Designers

Intonation

Expression of meaning can be accomplished through intonation, which refers to the modulation of a voice—the tone of voice when someone is speaking. Words can be animated to simulate intonation the way an actor might speak them, or to support the definition of a word.

This project is an animated conversation. Text is derived from a dialog between two or more characters—a conversation. Sequences 112|077 and 113|077 use the text of an excerpt from the film *Fargo*. The designers are called upon to create a sequence which communicates the *voice* of each of the characters involved in the conversation. The goal of the project is to visually portray the characteristics, emotions, personalities, actions, and reactions of the characters while they are conversing.

The particular clip of the film from which the text is derived is shown to acquaint the students with it, but imagery from the film itself is not allowed. There is no length requirement to this sequence. Students are encouraged to differentiate between each character through specific typographic and image characteristics rather than include the names of the characters as they are speaking.

Students are also encouraged to utilize type characteristics, movements, and rhythm and pace principles to show punctuation, rather than the actual symbols. For example, an actual comma would not be shown, but instead a pause would be inserted between the two words, either an *actual* pause in the sequence timing or a *visual* pause through word- or letterspacing.

112 | 077 Georgina Montana

113 | 077 Christian Kubek

Kendra Lambert

Instructor

Brian Mah

Designer

Numeric Sequence

This self-exploration of the student's personal design process as he investigates found structures and appropriated imagery in a type-and-image sequence was completed as an independent study. Questions that were posed at the beginning of the investigation include: Why apply motion to type? What are some of the uses and applications of spatio-temporal typographics? What are the places where moving type can exist? What is the cultural and technological context of moving type? How do you make type move, and what do you need? (114|078).

The sequence is based on the concept of a *countdown*, attempting to elicit emotional responses from the viewer through the determined order and pacing of numeric sequences. The piece is a fugue of type and image, opening with a stereotypical *shuttle countdown* and continuing with moments of anticipation, anxiety, and pause. The typography reinforces the act of *counting down* through the use of both words and numerals. Syntactical between-images provide visually stimulating transitions. The photographic images were recorded with a 35mm camera and composited into Macromedia Director™ as a stop-motion animation.

114 | **078** Brian Mah

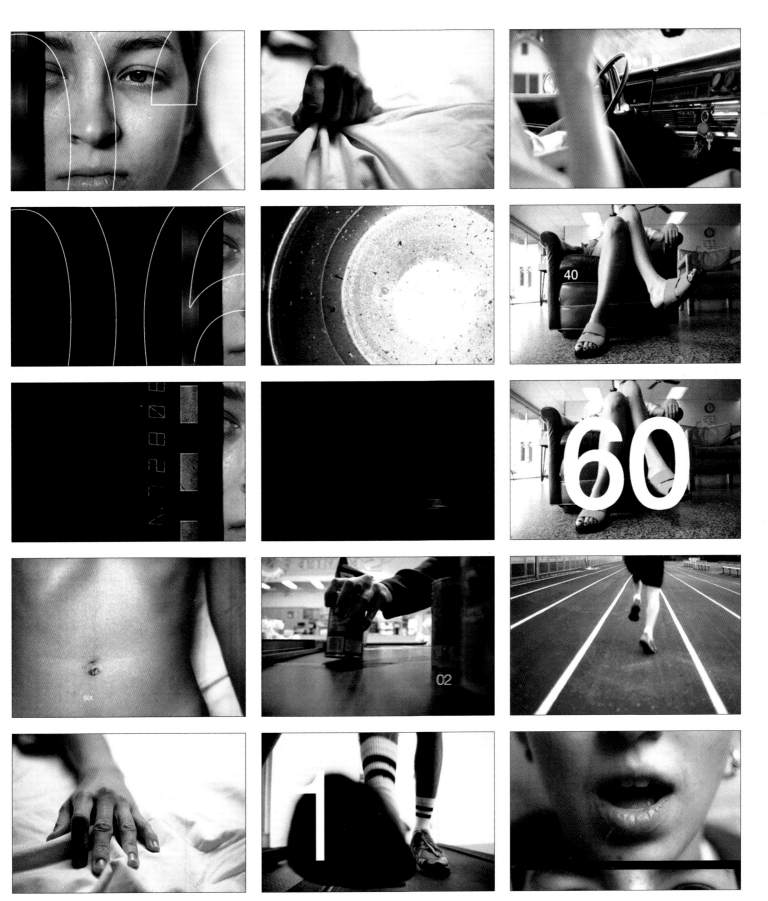

Design Education

University of Connecticut

Jeff Bellantoni

Instructor

Georgina Montana
Carissa Rutkauskas

Designers

Interpretation of a Novel

The content for this project, a final project that incorporates all of the fundamentals of moving type introduced throughout the semester, is the novel *The Necessary Hunger* by Nina Revoyr ©1997. Students attended a reading and discussion of the novel by the author, and were given a synopsis of the novel written by the University of Connecticut, as an attempt to begin collaboration with students outside the studio classroom. Further collaborations that could occur in this type of project, and would prove extremely beneficial to the student, include working in groups with writing, music, and film-making students.

There were no limitations set on this project, with the exception that the essence of the novel—the characters, the storyline, and the setting—should be communicated through the sequence. Suggestions were given that the sequence be approached as a promotion for the novel which would run on broadcast television, or as the main title treatment of a film version of the novel.

Two vertical lines created in cameraless-animation (scratch-film) effect interact, paralleling the competitiveness and passion that the two main characters in the novel, two female, high-school basketball players, held for each other. The structural hierarchy is audio-dominant, the text is narrated, and type plays a supportive role (115|081).

An extremely saturated image of a young woman is just one in a number of layers in this sequence, reflecting the deep confusion felt by the main character over her sexual identity, and the career decisions she faced after graduation. The simple but elegant type rarely moves beyond the horizontal center of the screen, while continually hiding and revealing the text (116|081).

115 | 081 Carissa Rutkauskas

116 | 081 Georgina Montana

University of Texas at Austin

Hendrikus Van Assen
Instructor

Tanya Chi
Kevin Conner
Brooke Howsley
Lauren Saunders
Elaine Shen
Kelly Stevens
Designers

117 | 082 Kelly Stevens

Type in Motion

A senior-level course in the design curriculum at the University of Texas at Austin investigated type in motion from the underlying question of how the communication of messages might be altered when the fourth dimension of time is added.

Students were asked to contemplate their extended roles as authors, designers, and producers—an inevitable collision of roles occurring in motion design. The two main components of this design discourse were to develop and design a typeface that was to be an expression of the subject matter for which it would be used, and to present and communicate information about the chosen subject matter in a time-based medium. An existing social and/or cultural organization in Austin, Texas was chosen by the student as the subject. The students established contacts with the organization, and in many incidents became participants and/or volunteers in an effort to get a full understanding of the organization's goals and operations.

To an appropriate audience, information about the organization would need to be communicated in such a way as to be informative, descriptive, functional, persuasive, and rhetorical. A component of the communication of the message was the development of a typeface that reflected the organization and would help express the meaning of its message. To minimize complexity, only lowercase letterforms were required in the typeface design.

The skill levels of the students involved in this project varied, so the expected level of complexity ranged from simple, using only typography, to the addition of still images, texture as background, video imagery, and sound. The conceptual realization of the project was valued over technical exuberance.

The project was divided into phases. Phase one involved the development of a storyboard, so the students would begin to think about the structure of the narrative and gain a better understanding of the significance of the sequence of events. Students investigated the development of narrative—how to set up a plot structure and in what order to show events, so that the story is told most successfully. Other inquiries included a look into what manner can the characters (objects, people, typeface) be developed so that they become both believable and intrinsically linked to the story. The environment, location, and context in which the story unfolds were examined, as were the transformation of both place and time.

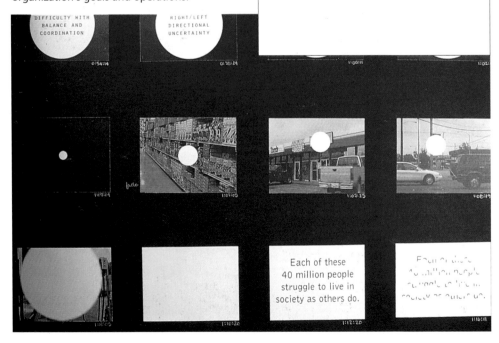

The second phase examined the concept developed in the storyboard and translated it into a sequence using software. Discussions among the instructor and the students covered transitions, kinetics, distance, speed, and duration. How word and image relationships behave when existing over time and in motion was addressed, as was what happens to visual hierarchy and reading order when the information is moving, as opposed to scanning static type and image, i.e. print-based media.

Focus, letterspacing and position, and scale are altered in sequence 117|082 (and the accompanying storyboard), which functions as an advocate for dyslexia awareness. The designer deliberately makes the message illegible, placing the viewer in the position of someone who suffers from dyslexia. In addition, the designer utilizes white circles to block the words on everyday things most of us take for granted, such as storefronts and gas pumps, emphasizing the importance of being able to read without difficulty.

Titled *(in)justice,* sequence 118|083 plays an advocacy role and questions the judicial process which sent a young girl to prison. It utilizes cut-and-paste-style editing, textural backgrounds, and a hand-drawn typeface to enhance the message.

118 | 083 Lauren Saunders, Elaine Shen

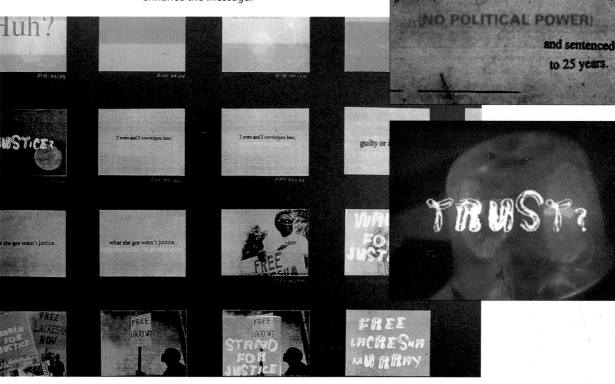

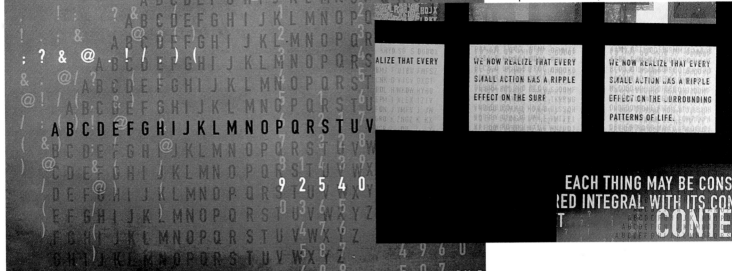

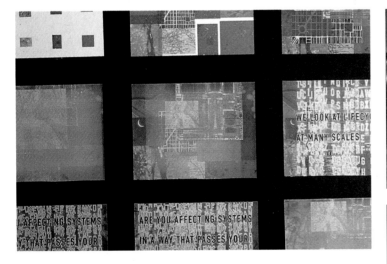

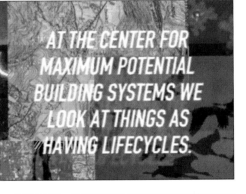

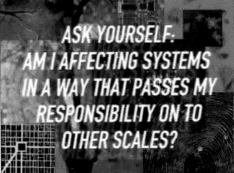

In sequence 119|084 the designer asks the viewer to reevaluate the context in which recycling is viewed, in an effort to promote a more conscious effort by humans to consider the ramifications of their actions on the environment. It utilizes layered images and a hard soundtrack to support its message. The sequence ends with the text *we now realize that every small action has a ripple effect on the surrounding patterns of life.*

Titled *Women and Their Work*, sequence 120|085 questions the stereotypes and generalizations placed on woman artists. Chauvinist quotes begin the sequence, then highlighted words increase in scale to eventually fill the frame. The sequence continues to highlight a series of accomplishments by women in an attempt to educate the viewer and break through the stereotypes.

Sequence 121|085 serves as an advocate for *Habitat for Humanity*, an organization in which volunteers build housing for the less fortunate. A single construction nail centered vertically within the frame is consistent throughout, as various uses for it are displayed. All the while the main title, *Habitat for Humanity*, slowly *builds* itself letterform by letterform, the underlying message appearing at the end, encouraging the viewer to *waste not one (nail)*.

Jeff Bellantoni

Instructor

Christian Kubek
Georgina Montana

Designers

Motion Typography and Design

The two type sequences represented here are self-directed projects—the visual component of the Senior Project course at the University of Connecticut.

An investigation into the basic theories and principles of design and the design process, *re:design* (122|086) employs text derived from questionnaires sent to a number of prominent designers throughout the world, asking them to reflect on their personal design process. The designer is experimenting with the fugitive nature of the medium.

122 | 086 Christian Kubek

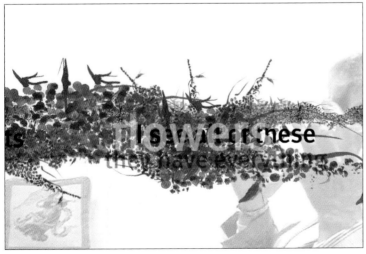

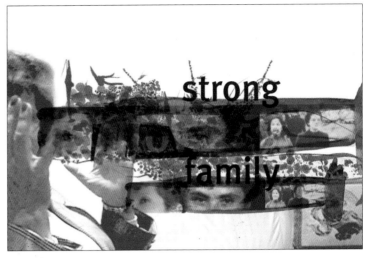

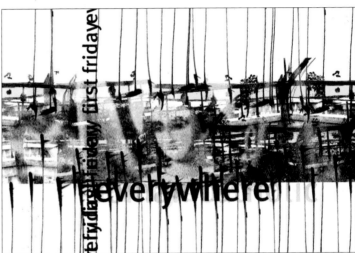

Columbia (123|087) is a short series of anecdotes that the designer chose to animate after interviewing her mother. Her mother recalls the joys, struggles, and tensions of a young woman growing up and living in Columbia. In addition to type, the sequence employs photographs, illustrations, narration, and traditional Columbian music.

Parsons School of Design

Cary Murnion
Instructor

Marc Cassata
Hanna Han
Agustin Llona
Kathleen McGowan
Designers

125 | 088 Kathleen McGowan

Motion Graphics

The following stills represent various projects from the Junior class Motion Graphics course at Parsons School of Design in New York City.

Sequence 124|088 is a redesign of the film title sequence for *2001: A Space Odyssey*. This version hints at the pace of the film itself, *2001* slowly moves across the screen to a haunting soundtrack, while the names of the actors float across the screen like space stations. The kerning of *2001* extends to eventually transition into the rest of the title: *A Space Odyssey*.

In this redesign of the film title sequence for *Enter the Dragon* (125|088), the designer is referencing martial arts without illustrating them, choosing instead to illustrate the pressure points of the human anatomy, which can be used to heal or hurt, depending on how they are utilized. This parallels the main character played by Bruce Lee, who is peaceful until pushed to his limit.

In the sequence title *Yellow* (126|089), the designer uses a poem that poses the question *what would the world be like if the word yellow didn't exist?* The words in various colors blur, stretch, and multiply to become the background of the sequence.

A full-length music video for rap musician *Common* (127|089) is a response to what the song means to the designer and the time period evoked from the sound and lyrics. Jazz is the foundation for the song, so the designer plays words off each other like musicians in a band. *Blue Note* record covers were a source of inspiration.

Still images taken in New York City provide the appropriately moody backdrop for this music-promotional sequence based on *Whole Black Styles*. The designer was not familiar with the musician, increasing the challenge to visually capture and represent the sound. An extraordinary synchronization occurs between image and sound (128|089).

124 | 088 Marc Cassata

Jonathan Milott
Cary Murnion

Instructors

Andrea Dionisio
Mike Helmle
Yu-Jin Lee
Rei Yoshimoto

Designers

Advanced Broadcast Design

The following stills represent various projects from the Senior class Advanced Broadcast Design course at Parsons School of Design in New York City.

The concept for sequence 129|090 is derived from a song by the musical group Dee-Lite. Allowing the intonation of the singer's voice to dictate the kinetics and transitions of the type, the designer intended the movement to mimic the dialog, as if the words were coming directly out of the singer's mouth. Bright colors enhance the silliness of the words and sound qualities.

Two designers collaborated on *The Plasma Project*, intended as a proposal to companies such as Grundig, Philips, Aiwa, and Mitsubishi, that they might lend Parsons School of Design four flat-screen televisions for a four-week period to be used for the Communication Design Senior Exhibition—held yearly. Rays of light illuminate the type in this technological style-driven sequence (130|091).

129 | 090 Yu-Jin Lee

Sequence 131|092, and the accompanying storyboard (Fig. 01), represent a self-directed project titled *Metaphrenie*. The designer wanted an opening sequence to his portfolio reel which demonstrated his work in a way that would show his design and technical skills, as well as introduce the viewer to his unique world of edgy visuals mixed with off-kilter sounds and beats. An intense viewing experience, this sequence has a mix of three-dimensional and flat graphics and creates a space within the frame that is both futuristic and chaotic.

This redesign of the opening film title sequence for the film *Blade Runner* creates a very simple and effective design, the type adhering to an ever-present grid. The grid is evident throughout, becoming an integral component of the design itself and creating a geometric look that reflects the technologically-driven future in which the film is set (132|093).

132 | 093 Rei Yoshimoto

Jeff Bellantoni

Instructor

Michele Granville
Carla Imperati
Kate Kenny
Aaron Lazauski

Designers

Motion Typography and Design

The sequences represented here are self-directed final projects from the Motion Typography and Design course at the University of Connecticut. Each designer chose a text as the inspiration for their sequence, in some cases incorporating video as a component for the first time in the course.

Type sequence 133|094 experiments with multiple layered words, deriving its content from an excerpt of *The Stolen Journal of Leto Atreides II, God Emperor of Dune,* by Frank Herbert. It also tests our ability to read moving words. The geometry of the composition is itself difficult to navigate while reading. The designer attempts to solve this problem by highlighting in red words the correct reading sequence.

The seven deadly sins are the conceptual basis for sequence 134|094, which limits the kinetic activity of the type and uses subtle but impactful imagery.

Text derived from Alan Lightman's book *Einstein's Dreams* is the content for sequence 135|095. Random video imagery from the streets of New York City serves as the backdrop, the faceless crowds and neon lights enhancing the meaning of the text.

A techno-beat and superbly altered pacing are just part of this electric sequence (136|095). The text was written by a friend of the designer. Abstract colors and forms derived from video imagery give a hallucinogenic feel to the sequence, but do not distract the viewer from reading the text.

133 | 094 Aaron Lazauski

134 | 094 Carla Imperati

X Y Z

Sonya Mead

Instructor

Abraham Blanco
Aaron Carmisciano
Rie Takeuchi

Designers

Poem in Motion · Moving Verse

These sequences were completed at the Art Institute of Boston. Students were asked to choose a poem as the content for their sequence. They began the project by writing a description of their understanding of the chosen poem, and specifying possible ideas and imagery choices.

They then diagrammed the poem in different ways, observing how the meaning of the poem changes when a particular word is isolated. They worked with each line in the poem, making visual and conceptual connections between the words, investigating the formal syntax and semantics that existed within the poem, as well as the explicit and implied references that existed.

The students storyboarded their concepts, working out the overall look and feel of the work, and choosing images and typefaces before proceeding to the animation.

137 | 096 Abraham Blanco

X Y Z

Bob Aufuldish
David Karam

Instructors

Franceca Bautista
Jason Botta
Ragina Johnson
Makiko Tasumi
Oanh Troung

Designers

Typespace: Character Emotion

Typespace is one of six courses at the California College of Arts and Crafts developed to familiarize students with the language of *new media*. In this sequence, a letterform animation project, the students were asked to animate a letterform so that it expressed the particular emotional state which the student was assigned. They could use only one letter—a successful project was one that communicated the emotion without any additional explanation (see **Intonation**, page 32).

Students were asked to consider their working methodology carefully and plan their sequence before beginning the animation. Each student investigated various typefaces and made sketches by hand or in Illustrator™ of keyframes to present their ideas, with the consideration and understanding that sound, color, and duration are crucial in communicating a concept. Emotions animated include: contentment (140|099), anger (141|099), foolishness (142|099), rage (143|099) and exuberance (144|099).

141 | 099 Ragina Johnson

142 | 099 Makiko Tasumi

140 | 099 Jason Botta

143 | 099 Oanh Troung

144 | 099 Franceca Bautista

Sonya Mead
Instructor

Abraham Blanco
Aaron Carmisciano
Designers

145 | 100 Abraham Blanco

Type in Motion · Designer Announcement

A fairly pragmatic project assignment given at the Art Institute of Boston. Students chose a designer or artist and designed and produced a *card in motion* with the intent of announcing a show of the selected person's work. Students were encouraged to consider the context and method of distribution of the announcement card they were designing, i.e. does it function as an email attachment, exist in a website, arrive by mail on a computer diskette or CD-ROM?

Fundamentals of animation, including easing in and out and timing, were introduced and discussed. Other fundamentals investigated included duration, transition, and speed, particularly in relationship to legibility. Students were required to produce story-boards prior to animating their sequence.

Sequence 145|100 mimics well the established style of typographer and designer Carlos Segura and type foundry T-26, and utilizes a techno audio track. Taking advantage of a wider-frame aspect ratio, this digital announcement card (146|101) for typographer and designer Neville Brody is both colorful and dynamic, combining both two- and three-dimensional letterforms and shapes.

X Y Z

Bob Aufuldish
David Karam

Instructors

Franceca Bautista
Dain Blodorn
Ragina Johnson
Jereon Mimran
Makiko Tasumi

Designers

Typespace: Navigation Space

This project from the Typespace course at the California College of Arts and Crafts investigates the intersection of text, meaning, interpretation, structure, space, and navigation. Students chose a haiku, short poem, or word. They then created a space that reveals multiple meanings and annotates the text. Use of limited imagery was allowed, but the projects had to work primarily in the typographic realm.

Students were encouraged to consider how the space would be constructed and how it might relate to the form of the text. Students experimented with how the space could allude to meanings or connections between meanings, and how the typography could function as a navigation device—how interactivity could be communicated to the user/viewer/audience.

Students first created a two-dimensional diagram that communicated how the space was to be constructed. Using three-dimensional animation software, they then produced their project as a fly-through animation. The animations demonstrate how the navigation works, although the complexity of the spaces varied. While the project did not have to be interactive, it did have to clearly demonstrate how interactivity would function within the space.

147 | 102 Franceca Bautista

X Y Z

I am silver and exact.

I have no preconceptions.

er and exact.

ave no preconceptions.

Dain Blodorn

150 | 104 Ragina Johnson

California Institute of the Arts

Geoff Kaplan

Instructor

Adrianna Day
Sophie Dobrigkeit
John Kieselhorst

Designers

Adrianna Day

Alien Type Forms

This highly experimental project investigating three-dimensional typographic form was given at the California Institute of the Arts.

The project brief reads:

You are an archaeologist or anthropologist with the ability to travel through time and space. You have traveled ahead in time to an uncharted planet. The population is extinct. You have come across the remnants, consisting of three or four objects, of the population's alphabet. It is your job to decode the objects you have found. Investigate the anthropological history of the letters you have found, focusing on the physical properties of the planet and how these properties dictated the form of the alphabetic objects discovered. The one rule imposed is that the objects must be three-dimensional. To begin, start by determining the nature of the planet's gravity and how the gravitational forces effect the object. You are encouraged to address whether or not the object is man-made and/or organic.

The conceptual leap involved in lifting type from its language-imposed flatness, into a world where the letterforms are released from stasis both conceptually and visually, remains a difficult stumbling block. So far, we've [designers] come across series of words spinning and flashing in every conceivable way. Seeing the word form as a whole, indistinct unit which veers and rotates as a clumsy block does little to represent the possibilities of how type—as image—is 'read' over time. Not only in the literal sense of the word 'read', but also how we have been trained to 'read' signifiers and characteristics. Different font faces have long been used in print to quickly display an attitude which enhances its typographic environment. Instead of literally relying on the passive stylistic signifiers of a plethora of font styles, the essence of fonts and letterforms as personalities unto themselves can be extracted when creating a whole world of conversing characters. Then the expression of type will be seen as not only both form and metaphor, but letters which can reveal a relationship between one another over time. At this point the letters can express multiple levels of meaning simultaneously. It is here, in this simulated environment, that all these visual configurations—of letters, as creatures, together forming words, in a larger interaction with other words, and with an even greater interaction with the environment itself—all collapse into a single hierarchy which is seen as indistinct and parallel. Viewed as separate components but 'read' as a whole at the same time. Letter, word, and creature are seen encountering one another profoundly; adding and building to one another's layers of identity and information. These coagulating levels of reading have the potential to create a very mixed, beautifully interacting message that is truly unique to an environment of type in motion.

Essay by Adrianna Day
California Institute of the Arts

How is the screen, in essence a two-dimensional plane, any different from the page? The page and the screen both afford us the ability to treat the planar surface as two- or three-dimensional space, but is the screen really a planar surface, or is it a voluminous space? Even though we perceive images in motion on the surface of the screen (charged electrons behind glass), we do not isolate them to that plane in the same way that images are statically affixed to a page. Is this because the screen is a spatial volume? Or is it because the screen composes a temporal volume in which we, the perceiver, become immersed?

Doesn't the behavior of type as an image, as a form, 'on' or 'in' screen have as much potential meaning as its legibility as a letterform, word, or phrase? Does the motion of type redefine for the screen what is typographically 'legible' to the viewer? Isn't readability the important

Sophie Dobrigkeit

John Kieselhorst

factor? Conversely, what sort of limits does the fourth dimension—time—impose on the content of motion typography itself? Does motion typography require a specific kind of text, one based in oral tradition, narrative, or the visual meaning of word arrangements themselves, such as concrete poetry?

Excerpts from an essay by John Kieselhorst
California Institute of the Arts

X Y Z

Geoff Kaplan

Instructor

Adrianna Day
Sophie Dobrigkeit
John Kieselhorst

Designers

John Kieselhorst

Destabilizing Figure-Ground

This project at the California Institute of the Arts focused on the two-dimensional picture plane, attempting to destabilize figure-ground relationships. Students were investigating one main issue: with a long history of non-dimensional, static mark-making, how do graphic designers respond when confronted with a technology that challenges their understanding of graphic mark-making, namely typography?

Technology is used to make marks, the alphabet is an example. Mark-making informs mark-making technology, and vice versa. The alphabet is a technology. The alphabet pushes technologies, as pen and computer. Pen and computer push back on the alphabet. How does technology push back on mark-making systems, on the properties and perception of marks, on readability (as image) and on legibility (as word), and on meaning?

What happens if the two-dimensional plane is extruded in time? The condensed filmstrip re-expands, creating the possible states of a shape being figure, being ground, being ambiguous. The perception as figure or as ground can be actively triggered through motion. A sequence of dots can form the image of a continuous line. The brain fills in the blanks (this is basic gestalt theory). Can this concept be extruded in time? Can a dotted sequence of images form a continuous movement? The brain fills in the blanks in time, creating a continuum of time. How could this concept affect readability and legibility?

What happens if the mark on a two-dimensional plane is not expanded over time, but rather in space, entering a three-dimensional volume? What if a piece of type becomes architecture—in space? Type can be extruded along one axis, legible (forming a word that we recognize) from one perspective. Other perspectives show an image, readable as image only, not as text.

Type can be rotated, creating a multi-perspective legibility. Can type be legible from different perspectives? If type in time has properties of film sequences, the type in volume has properties of physical objects.

These ideas expand our concept of motion graphics. How could all of this be applied to a paragraph? To a lengthy text? To a novel? To a phone book? How would all this play out in a two-hour feature film? As a signage system? As a library of motion?

Excerpts from an essay by Sophie Dobrigkeit
California Institute of the Arts

Sophie Dobrigkeit

Adrianna Day

Design Education

California College of Arts and Crafts

Bob Aufuldish
David Karam

Instructors

Franceca Bautista
Dain Blodorn
Jason Botta
Ragina Johnson
Jereon Mimran
Oanh Troung
Kim West

Designers

Typespace: Narrative Structure

This project from the Typespace course at the California College of Arts and Crafts deals with how a narrative structure is translated into space and time. The students created animated sequences that translated the essence of a story of their choosing into an abstract typographic environment.

This project resulted in fascinating sequences that bring two- and three-dimensional letterforms into a virtual narrative environment, in many instances the words of the narrative literally functioning as actors.

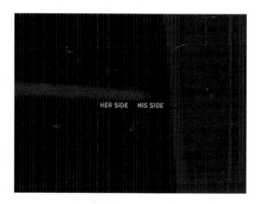

152 | 110 Dain Blodorn

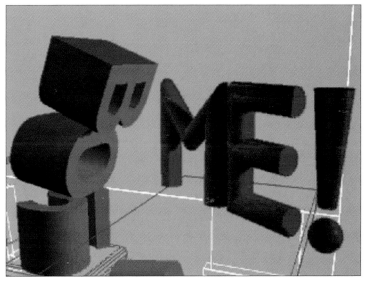

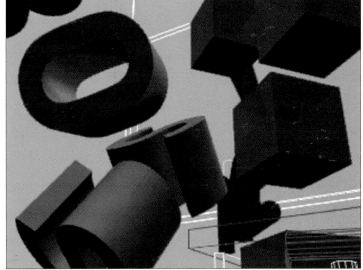

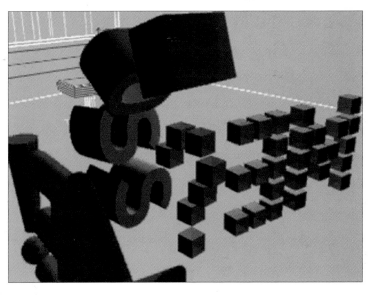

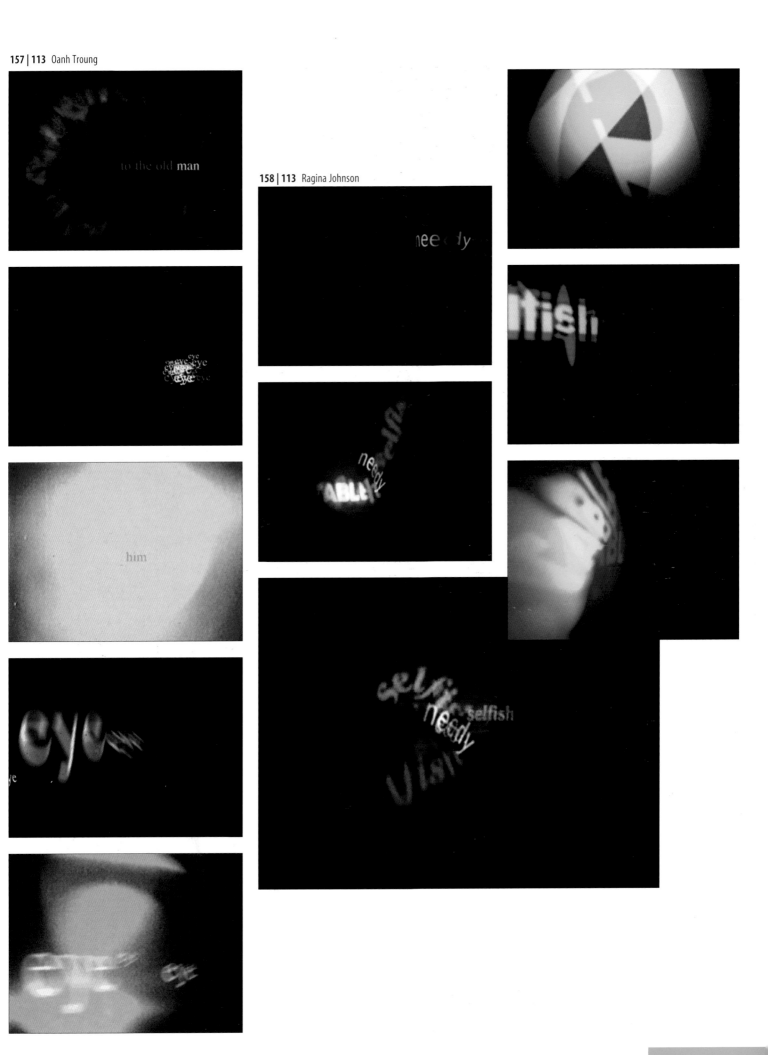

158 | 113 Ragina Johnson

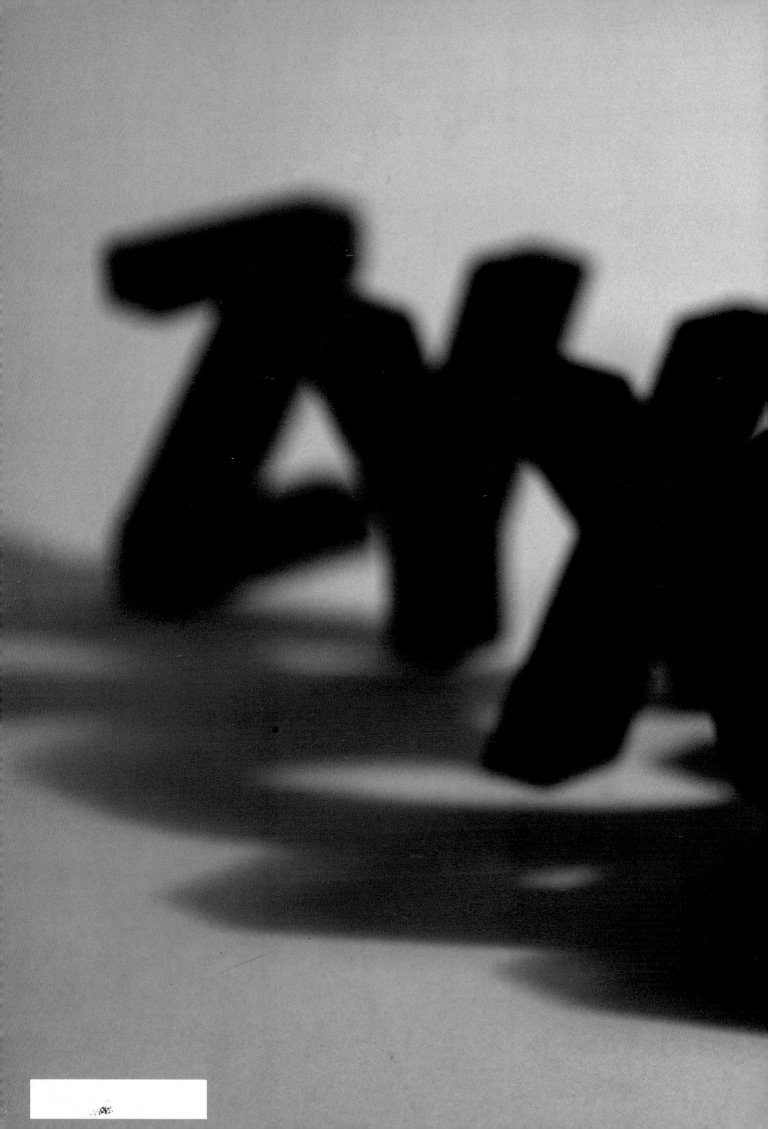

Professional Profiles

The projects presented in Section 2 purposely have a theoretical and experimental emphasis. This is the luxury of academia: the absence of the client. But a dearth of real-world limitations does not necessarily lessen the importance of these projects. A carefully constructed project brief isolates *specific,* and important, aspects of spatio-temporal typography that a student can identify, explore, learn, and even fail in using before he or she succeeds. The safety of academia allows the trial and error of experimentation and learning to come of age before the student ventures into the professional world.

The five profiles presented in this section offer a wide spectrum of professional practice in spatio-temporal typography: film and television titles, television program and channel identities, typographic editorials and performances, and human-computer interfaces. Each of these profiles has a unique visual voice and engages a specialized creative process that adapts to, and fulfils, the formal and functional demands of our information-rich communication cultures.

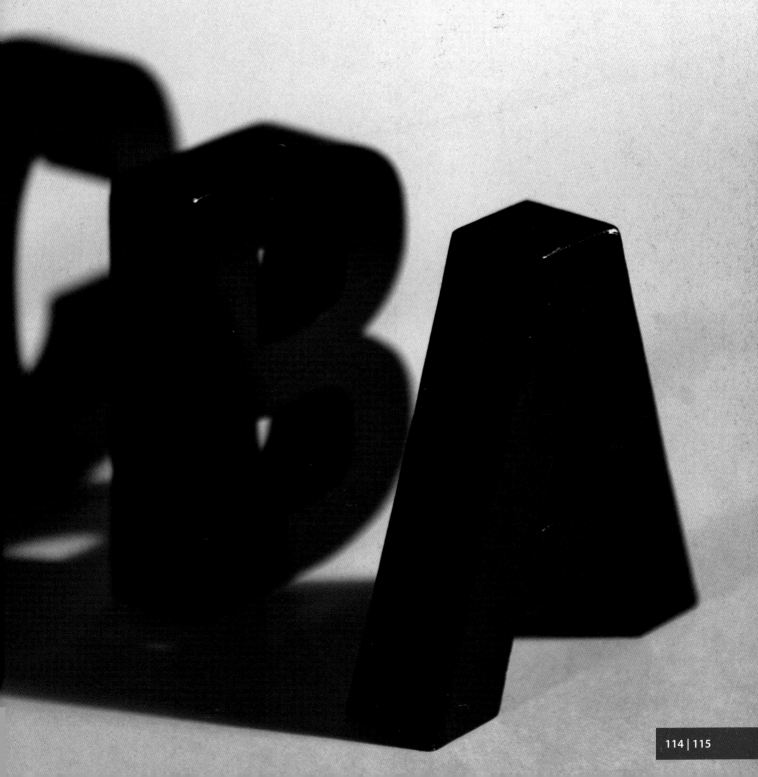

DePablo Productions

Pablo Ferro has been hailed a genius by such legendary film directors as Stanley Kubrick, Jonathan Demme, and Gus Van Sant. 'In the world of painting there is only one Pablo, in our world of film there is only one Pablo, Pablo Ferro,' Michael Cimino claims. Raised on a farm in Cuba, Ferro's journey began when he emigrated to New York City. In the 1950s, after he graduated from art school, he was hired as an illustrator for Atlas Comic Books. After a successful decade in comics, Ferro brought his visual genre to life on film, producing commercials for a wide range of clients. In 1961, he formed a partnership with Fred Mogubgub and Louis Schwartz with the intention of bringing art to the television commercial. Ferro developed a unique repertoire of editing techniques that have since become industry standards: the quick cut; stop-motion animation with hand-rendered letterforms; in-and-out zooms with extreme close-ups and croppings; montage transitions with letters of live-action footage; and the use of multiple-image modules within a single viewing frame.

In 1962, Ferro transitioned into feature films when he was hired by Stanley Kubrick to create the title sequence, trailers, and television spots for *Dr Strangelove*. This led to his contribution to *A Clockwork Orange*, and also allowed Ferro to move from title design to film direction. He directed trailers for other films, including *Jesus Christ Superstar* (1973),

Courtesy of Title House Digital, LA

Courtesy of Title House Digital, LA

Scenes from a Marriage (Ingmar Bergman, director, 1973), and *Zardoz* (1974). Ferro was second-unit director for the film *Midnight Cowboy* (John Schlesinger, director, 1969) and editor of the 'bedroom-TV scene'. He also was supervising editor on Michael Jackson's music video *Beat It* (1983), and co-director, with Hal Ashby of the Rolling Stones concert film, *Let's Spend the Night Together* (1982).

Ferro also directed his own feature film, *Me, Myself and I* (1992); directed, produced, and edited *The Inflatable Doll* (1987); and created the short films *Five Minutes Late* (1970) and *The Bridge* (1968). Ferro has also had cameo appearances in several films such as *Philadelphia* (Jonathan Demme, 1992), and several films by Robert Downey, Sr, *Hugo Pool* (1997), *Greaser's Palace* (1972) and *Jive* (1976). At heart, Pablo Ferro is a film title designer *extraordinaire* and continues to collaborate closely with major studio directors and producers.

Presented on these pages are two other classic films for which Ferro created the opening title sequences, *Citizens Band* (1977) and *Bullitt* (1968). For *Citizens Band*, Ferro used extreme close-up shots of a CB radio set to provide a context and backdrop for the bold title type. For *Bullitt*, Ferro also made use of technical equipment to establish context. He took this another stage further by using the type treatments as another screen in which to crop in live imagery and create transitions between scenes.

161 | 118 Burlington Mills

Courtesy of Title House Digital, LA

162 | 118 The Thomas Crown Affair

Courtesy of Title House Digital, LA

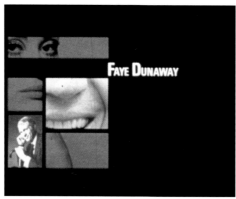

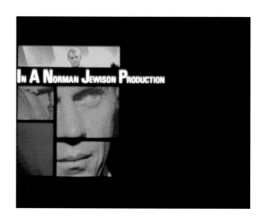

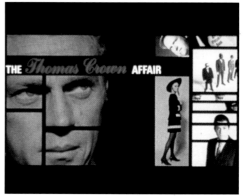

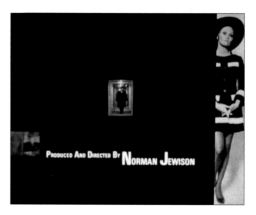

Burlington Mills

For the award-winning Burlington Mills television commercial, presented on the left, Ferro created a stop-motion animation of interweaving color strips to simulate the weaving of textiles for the award-winning Burlington Mills televeision commercial (left).

The Thomas Crown Affair

In the opening title sequence for the original version of *The Thomas Crown Affair* (Norman Jewison, director, 1968), Ferro used the split-screen technique that he developed for several television commercials. What begins as a grid of same-size video monitors evolves into a matrix of various-size and color modules, *à la* Piet Mondrian. As the sequence unfolds, imagery from clothing fashions of the time, and a polo match in the film, subdivide and compress into modules in order to capture the decadence and wealth of the characters in the film. By showing several frames of this scene simultaneously, Ferro was able to reduce the opening sequence, which was originally 6 minutes, down to 40 seconds.

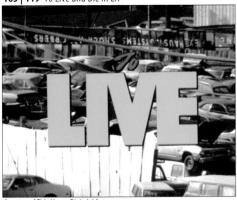

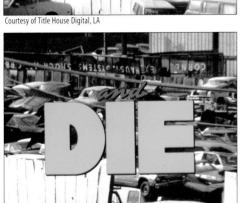

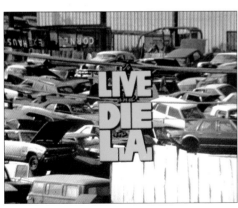

The sequences on this page present the various typographic and lettering techniques that Ferro has mastered over the years, most notably, the hairline hand-lettering style, revived for *Men in Black* (1997). This trademark genre of Ferro's was first used in the opening titles for *Dr Strangelove* (Stanley Kubrick, 1964); and again in the Talking Heads concert film, *Stop Making Sense* (1985).

Courtesy of Title House Digital, LA

Woman of Straw

In the opening title sequence for the film *Woman of Straw* (Basil Dearden, director, 1964), Ferro was able to adapt his television-editing techniques to the movie screen. Ferro created a series of simple, symbolic images that signify the story: a wheelchair, a woman, and a man. He filmed these stills with high-contrast film which reduced all halftone color information to simple black and white. Filters allowed the white to be replaced with other colors. Ferro edited these images, in positive and negative exposures, together in a seamless transition by using formal focal points, zooms, and layering. For example, the sequence on this page begins with the wheelchair centered within the viewing frame. The image zooms out to reveal the same wheelchair in the center of the pupil of an eye. The eye zooms out to reveal the eye belonging to the face of the main character of the film.

To Die For

Ferro worked with his son, Allen, and director Gus Van Sant on the film *To Die For* (1995). Of his creative process for the opening titles, Ferro states, 'This was a story where you needed to know the character before it started. What I did in the front was create, through the tabloids, what she wanted to be so everyone could understand the movie. It's a very important part of the movie; without it, it takes the audience too long to get into it.'

For the title sequences, Ferro revived the technique he used in *Woman of Straw*, and successfully adapted it to the story he wanted to tell the audience. Here, Ferro created a montage of media vehicles—tabloid covers, word bites, faces, and headlines—at various levels of cropping to establish the main character and the public hype of her misdoings. Ferro also takes advantage of the relatively low resolution of newspaper printing—consisting of visible dots in patterns that form an image—and zoom techniques to literally transform recognizable form into an abstract pattern of dots.

Courtesy of Title House Digital LA

and
MATT DILLON

Music by
DANNY ELFMAN

Courtesy of Title House Digital, LA

FMS Films

The sequence presented on this page is from the promotional film Ferro made to announce the opening of his New York studio, Ferro, Mogubgub & Schwartz, in 1961. Ferro chose bold, slab-serif letterforms for their ability to command a small viewing frame. A simple palette of white forms on a black background only reinforces this emphasis. To bring these letters to life for the audience, Ferro used simple stop-motion animation techniques with cut letterforms.

MYOB

Ferro revived his trademark cut-and-paste animation style with illustrated letterforms for this title sequence for a new television pilot, *Mind Your Own Business.* The initial capital of each word in the title enters the viewing screen and does a little dance to announce itself before its remaining letters join in to complete the word. When the full title is complete, the supporting characters leave and the initial caps re-enter, alone, to perform in line fashion and change clothes—typeface styles—before the viewer's eyes in quickcut fashion. A final twang of the electric guitar in the accompanying sound design causes the letters to flee suddenly to allow room for the creator's name, Don Roos, to fill the screen. The 'D' in Roos' name vibrates to the final reverberation of the guitar.

Discovery International:

Behind the Scenes

Travel ID

Nature ID

Savage Sun

ESPN International IDs

Founded in 1997 by creative director and principal, Joel Markus, M, Inc. is an award-winning, multi-disciplinary design firm that specializes in creative direction and design for national, and international clients. M is committed to providing innovative, high-quality, conceptual design that withstands trends in the market. M invites clients into a collaborative exchange in order to carefully formulate an appropriate solution to fit needs and goals. A particular strength of M is the ability to put together a unique team to execute a project. At the same time, M maintains consistency in creative direction on projects that are part of a broader campaign or design system. M is dedicated to developing long-term relationships with clients. This is encouraged by a devotion to visual excellence, and integrity in establishing and maintaining business relationships. M, Inc. has garnered national and international recognition in design for The Learning Channel; Discovery Channel USA and International; Home and Garden Channel; and ESPN USA and International, in addition to work for regional television stations.

Discovery Channel International: Behind the Scenes

The Discovery Channel is known for its adventure-packed programming. If the subject is nature, the viewer might find herself in an underwater cage surrounded by hungry sharks. If the topic is history, the viewer might find himself aboard the fated *Titanic* as it sails across

Title Treatments

Tape Format: Hand Written 1

Spanish Tape Format: Treated Type 2

Slate Format: Treated Type 3

Portuguese 4

the ocean. The function of the identity spots for this channel require the same fast pace and action of its programming.

Behind the Scenes is a series that documents the making of some of the more daring programs on the Discovery Channel. As the title suggests, the idea is to bring the viewer into a realm that is usually 'off-limits' to public eyes. The treatments on this page illustrate the transitions, which are devices used to create a link between two or more segments of film. Here, a background bed which contains the Discovery Channel logo is used to create a sense of lifting and revealing. A hand-held camera zooms back and forth, in and out, to create a sense of adrenaline rush.

The effect of the transition is presented below. The live footage of the introductory scene breaks away to allow the title, *Queen of the Elephants*, to emerge. The transition matte begins as a background element that supports the title treatment. This device then swipes the entire viewing screen to reveal the complete Discovery Channel logo. Behind the logo is a director's clapboard to punctuate the opening. This object—a symbol for a break in the action and the process of film-making—is used in the final sequence to the right.

Behind The Scenes: Close Treatments

Transition Matte

Background Bed

Transition Treatment

Background frames with titles

Courtesy of Discovery Channel International

Discovery International: Travel ID
Revised 11/13

1. Window/Porthole slams shut.

2. Area fills up with water or window is submerged into water.

Titanic footage layered into scene.

3. Metal Panel slides over porthole window.

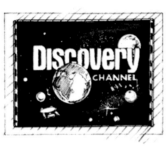

4. Inner panel opens up to reveal space travel.

5. Space footage is layered with Discovery logo

6. With a quick twirling motion Discovery comes into frame.

7. Camera zooms from birds eye view to see that the Discovery logo is actually a weather device.

Raging planet footage, i.e. tornados and hurricanes layered in the background.

8. Wind speed indicator is spinning in both directions. Storm clouds, lightning and debris is flying all around.

9. Robotic claps come from top and bottom transitioning over existing scene.

10. Robotic devices meet together and tube mechanisms fills with substance and travels to center. Steam puffs out.

11. Robotic device comes apart to reveal manufactured logo. As logo is revealed, globe is levered into position.

Discovery Channel International: Travel ID

Discovery Channel's incorporation of state-of-the-art technology for producing its features is the catalyst for the direction of this ID spot.

M created a series of transitions; guiding the viewer deep into ocean waters, glancing out into space, stimulating the wind blasts from a hurricane, and finally into becoming part of a robotic process. The Discovery logo was progressively introduced throughout. The storyboard illustration on this page presents the concept before it is actually produced. The storyboard is a valuable aid in working out the sequence—from general concept to typographic detail. Sound design was strongly influential in making the actions of each transition feel more dramatic.

Courtesy of Discovery Channel International

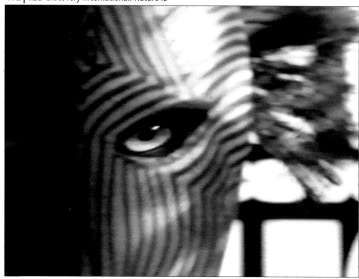

Courtesy of Discovery Channel International

Professional Profiles

Professional Profiles

M: Design + Direction, Inc.

Discovery Channel International: Nature ID

Animal masks were used to introduce the theme of human storytelling, pertaining to a human's relationship with the natural world. Elements such as sticks, shells, bark, straw, and feathers are part of a primitive palette in the creation of the masks used in this ID spot. These elements were interwoven with footage of animals on the run or in chase.

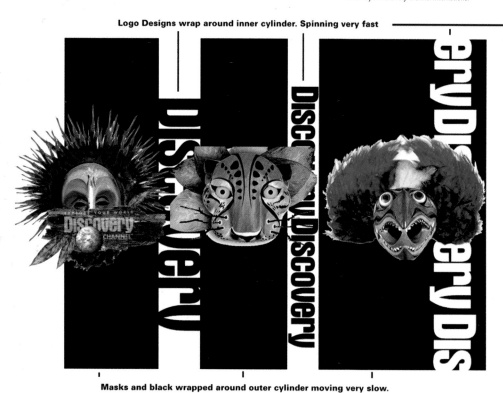

Logo Designs wrap around inner cylinder. Spinning very fast

Masks and black wrapped around outer cylinder moving very slow.

SPIN: Schematic

Layering of multiple detailed elements allows the viewer to bring a fresh perspective with repeated viewings. Repetition of the spinning Discovery logo also helps achieve a feeling of overall coherence for the piece. Sound design, that includes samples from native drums to animal chatter, becomes an integral part of the visual story told before the eyes of the viewer.

The arrangement and juxtaposition of real animal footage and symbolic animal masks is intentional. These contrasts create both the identity of the Discovery Channel and a particular meaning for the viewer.

The schematic diagram on this page illustrates the device used to create the identity for this ID spot. When captured on camera, the spinning cylinders synthesize in a blur of imagery and text. The masks serve as transition devices that allow the insertion of live footage from the program. Two cylinders are mounted vertically on a rotating ring, with one cylinder inside the other. The Discovery Channel logos wrap around the inner cylinder, which spins fast. By contrast, the outer cylinder, holding the primitive masks, spins more slowly.

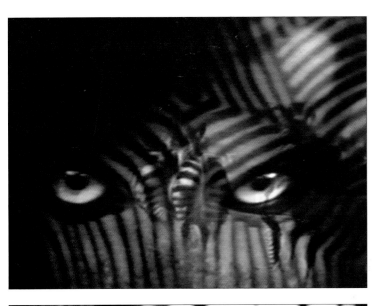

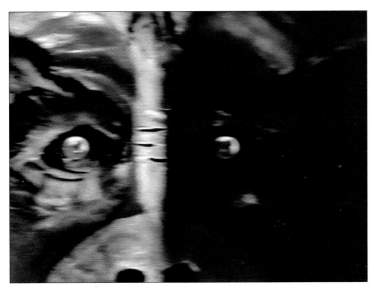

Discovery Channel International: Savage Sun

The undeniably symbolic impact of fire is the primary thrust of this title sequence. The letters that form the words SAVAGE SUN are ablaze as they file into place and form themselves to present the opening to this Discovery Channel program.

173 | 130 Discovery Channel: Savage Sun

Courtesy of Discovery Channel

ESPN International IDs

Using the natural graphic representation of sports through color, energy, and structure was the visual catalyst for this international campaign for on-air and print. The basic ingredients used were: The Fan, The Athlete, The ESPN Banner, and The Event. M carefully blended these together to form a series of visual solutions that celebrate ESPN's continuing sports coverage across the globe.

175 | 131 ESPN International: ID 1

Courtesy of ESPN International

174 | 131 ESPN International: ID 2

Courtesy of ESPN International

Courtesy of ESPN International

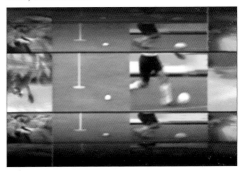

3 Ring Circus

A&E Program IDs:

The Detective: Crime Genre

The Script : A&E Original Movies

Showtime: No Limits

13th Street Danger Reel

RTL ID

The Evolution of Ideas

Target: Sign of the Times

Sony Entertainment TV

Teleuno ID

In 1994, entertainment industry promotion and marketing veteran, John Sideropoulos, and Emmy® award-winning broadcast-design visionary, Jeff Boortz, assembled an extraordinary team of top-level talent from the visual communications industry to launch 3 Ring Circus. Within a year, the company established a formidable reputation in the broadcast design industry for its visually arresting blend of strategic design, graphics, and live-action production. The company's inventive expression of brand identities has raised the industry bar, garnering multiple awards from organizations such as the Broadcast Designers' Association, CTAM, Academy of Television Arts & Sciences, and The New York Festivals. 3 Ring Circus has successfully launched and re-positioned channels, networks, and programs for every major Hollywood studio, as well as for an impressive roster of media and entertainment companies around the world.

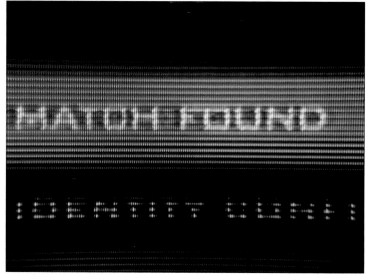

In the rapidly emerging age of convergent media, 3 Ring Circus has evolved to become one of a handful of multi-faceted, full-service, creative agencies situated where entertainment and new technology meet. 3 Ring Circus' commitment to the evolution of the creative process is cemented by the company now applying its strategic and ever-more critical creative approach across all media where brand visibility, definition, and relevance are essential.

With a process that is as much intuitive as it is collaborative, 3 Ring Circus brings unprecedented concepts and ideas to life by developing an open exchange of communication with its clients to determine the most effective visual expression of their brand and their message. It is this philosophy that provides an ideal working environment for like-minded talent to fuel the creative spirit both on artistic and business levels. Fostering this relationship-building approach is the cornerstone of the company's moral integrity.

177 | 132 The Detective: Crime Genre

Courtesy of A&E Networks

A&E Program IDs

A&E (Arts and Entertainment) provides in-depth programing that often takes a closer look at people, situations, and historical events. A&E dwells and draws its richness from the details of the stories it tells. In a series of live-action genre IDs, the A&E logo is found embedded in the images of historic and contemporary events. This seamlessly brands the network in the genre programming that it offers. Typography was used to express narrative ideas in an active voice. Using a variety of techniques, from shooting type on monitor screens to three-dimensional distortion animations in Flame, the type conveyed as much emotion and dynamism as the live action it was composited with.

The Detective: Crime Genre

An FBI agent is running a search on a suspect fingerprint. The computer breaks down the print into points and vertices in a scanning process and then begins to cross-reference a multitude of possible matches; 'Match found' flashes on the screen. The two matching prints draw on side by side. The detective superimposes the two prints. As they overlap, the print causes a *moiré* effect that reveals the A&E logo in the composite. Typographic animations were shot on a monitor screen to give the type a degraded, organic, and textural style.

The Script : A&E Original Movies

The Script is a surreal trip through the film-making process to the source of a film-maker's inspiration—the script. 'The journey' explores the relationship between the writer and the director in visual/typographical terms. The viewer travels through the eye of the director. We enter his mental space. Inside this space, the writer types madly as pages of the script are blown from his desk, creating a stormy, surreal environment. Words of the script are blown off the page and out through the eye of the director, becoming his stage direction: roll camera, action, and cut.

178 | 133 The Script: A&E Original Movies

Courtesy of A&E Networks

179 | 134 Showtime: No Limits

Courtesy of Showtime Networks

Courtesy of Universal Pay Television

Showtime: No Limits

The objective within the on-air redesign of *Showtime* was to communicate clearly the positioning statement of 'No Limits' and to separate the network within the premium movie network niche. The no-limits concept was conveyed through the moment of release, the moment when structure changes, and the tension is broken. *Showtime* was expressed as anything but conventional through the creation of the distinction 'No Limits'.

The IDs took on an abstract expression of that moment of release. Any surface or substance is a collection of atoms. These molecules are held together by pure atomic magnetism. By breaking that magnetism, the moment of release is realized in an abstract fashion... the surface tension of water, that is broken by a single drop... breaking glass... an inverted explosion...

Each organic, live-action element created and formed the *Showtime* logo and type. Mercury reacted with oil when disturbed by a ball bearing, to form and reveal the SHO icon and logo type. This ID was shot at 600 fps and played in reverse to achieve the languid animation quality of mercury. The final logo was composited and revealed by the horizontal motion of the ball bearing. The second ID utilized an electromagnetic force, ball bearings, and a shallow tank of water to convey the notion of no limits and release through the hero of the ID— the SHO icon and logotype.

13th Street Danger Reel

Danger Reel is a show that features episodes loaded with natural and man-made destruction, stunts, and dangerous situations. The objective was to package the show with a riot of images and typography that captured the destructive nature of the show. The opening was broken down into four segments that represented the range of features on the show. Each segment was edited to create a surge of energy reminiscent of an oncoming riot. Typographic elements were distressed and used to punctuate peaks in intensity.

Courtesy of RTL

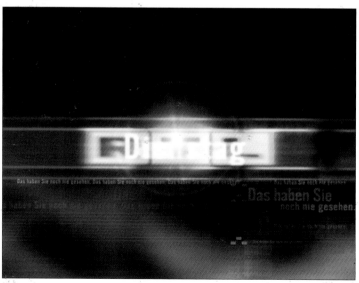

RTL ID

RTL, Germany's leading general-entertainment network, required a promotion package as an extension of, and evolution of the network aesthetic. The spectrum of color found in the logo animation was the point of inspiration for the evolution of the look into the specific promo elements.

The design solution utilizes an energetic blur animation to build excitement and launch the viewer into the promo. A geometric structure was used as a base upon which type animations were combined with a spectrum of color and light. Different scales of the RTL tagline, 'Das haben Sie noch nie gesehen' ('You have never seen anything like it')were animated on several layers. The type was accented by iconographic, cycling rectangles derivative of the RTL logo.

The typographic animation was based on a structured grid, accentuating the horizontal and vertical attributes established by the graphic transitions. Though much of the grid is implied with typography, line-art elements throughout the animation help to substantiate and strengthen it. Five color variations were created, providing maximum flexibility in the promotion of the wide range of programming on RTL.

The Evolution of Ideas

The purpose of the animation was to convey a sense of evolution through the element of typography, and inspiration as a stream of consciousness through the collage of imagery it supported. The animation was created to support a panel presentation discussing the creative process and how a concept evolves from a mere kernel of an idea to the final animated product.

Evolution and progression were illustrated in a very simple and literal way, by building each element of the typography letter by letter. As each wired frame letter animated and formed, the theme of the animation is revealed, finally resolving as the title of the session. The animation was achieved using live-action elements combined with typographic 2D and 3D animations.

183 | 138 Target: Sign of the Times

Courtesy of Target Stores & Peterson, Milla, Hooks

Target: Sign of the Times

The concept behind the 30 second spot *Sign of the Times* for Target is selling a lifestyle, an attitude, a way of living. The idea explores the Target bullseye as an iconic language, and the bullseye icon is the symbol of the language. It appears everywhere and is on everything. It is the alphabet of style, the symbol of sophistication, and the meaning of modern life. If you are stylish, contemporary, individual, and, most of all, fabulous, you understand the language of Target: *Sign of the Times*.

The objective was to make a statement that no other brand could make, and what better way to do that than with the logo? The Target bullseye is the perfect vehicle to speak directly to consumers and clearly separate Target as a place for not only great value but also fun, with attitude and style.

The Target bullseye, used in a graphic manner through live-action environments, created a unique world that clearly communicated the Target brand. Creating wallpaper, fabric, and customizing props, resulted in a unique look that separated Target not only within its specific market niche, but also attracted attention from previously untapped venues.

Courtesy of Sony Pictures Entertainment, Inc.

Sony Entertainment Television

The Modern World concept does not identify diversity, but rather aspires to bridge gaps and celebrate what is mutually shared among people in today's world. Among this is state-of-the-art technology—long associated with the Sony brand image—and the enjoyment derived by quality entertainment.

The environment of Modern World is defined by a series of stylized spaces that are warm and colorful. They open up to dramatic skies that keep them airy and tied to reality. The architecture creates boundaries that draw us into a more intimate setting, a reflection of how modern technology has brought people around the world closer together.

The Sony Entertainment Television logo is the driving force behind each of the four ID spots in the package. The hero element is a 3-dimensional 'S' that is transformed and manipulated through interaction with the environment and the talent. Each ID resolves with the 'S' being contained by the logo frame in a marriage of physical and graphic worlds. The IDs collectively express a range of attitudes from comedic to dramatic, reflecting the programing found on the channel.

Teleuno ID

The goal of the redesign of the Teleuno on-air package was to reinforce the channel name through the franchise genres within the Teleuno program base. Each ID reinforced the genre through the use of color, texture, mood, and tone.

The number '1' as a tangible object became the unifying theme throughout each element of the package. Each ID interpreted the '1' in a different way for the daytime, prime-time, and action blocks. This reinforced the network identity while also featuring the characteristics of each franchise.

Graphic type animations reflective of the tone of each ID, in conjunction with the live-action '1' element, resulted in a package that not only conveyed the emotional qualities of the network but also communicated to the viewer what type of channel Teleuno is.

185 | 139 Teleuno ID

Courtesy of Sony Pictures Entertainment, Inc.

Typographic Performances

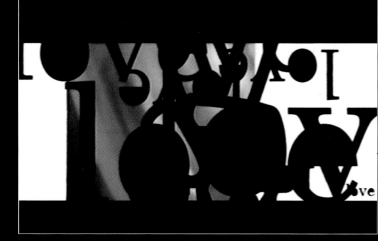

Paul Sych, founder of the Ontario-based design studio, Faith, has academic training in design from the Ontario College of Art, and music from York University, Canada. A jazz musician at heart, Sych embodies both his musical and visual passions in his creative processes and solutions.

Sych's primary goal is to strengthen the connections between the musical and visual arts, both share a dependence on tools—the instruments—of expression. And both share the aspects of change over time and movement through space. Sych uses type and other graphic elements as visual notations in his compositions, much like a musician uses aural notations in a performance. Sych likens himself to an *improvisational* jazz musician: an arranger of connections, sequences, and parts; a painter of rhythms and riffs.

Of primary importance to Sych's process is maintaining the ability and freedom to express himself without hesitancy. Sych has focused his design and type sensibilities towards this goal. To fuel this he seeks inspiration from his fellow musicians. But Sych does not focus on the externalization of their musical form. His interest is where this begins—the inside; this, Sych asserts, is the root of the artistic voice.

Equally important to understanding the methods is the mastery of the the means—the tools—of expression. Sych's uses of the tool—in his case, the computer and other digital technologies—is not a conscious or mechanical one, but a part of a larger intuitive process.

Sych admits that it is sometimes difficult to form connections between the musical and visual arts, but this strengthens his passion. Presented on these pages are sequences from Sych's vast palette of time-based experimentation. Each is a visual editorial—with performing type—on some aspect of contemporary culture. All are visually dynamic. Most importantly, they represent a highly personal creative vision that is not restricted by the dictates of clients or commerce.

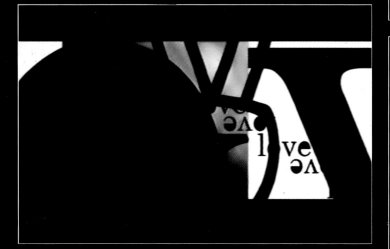

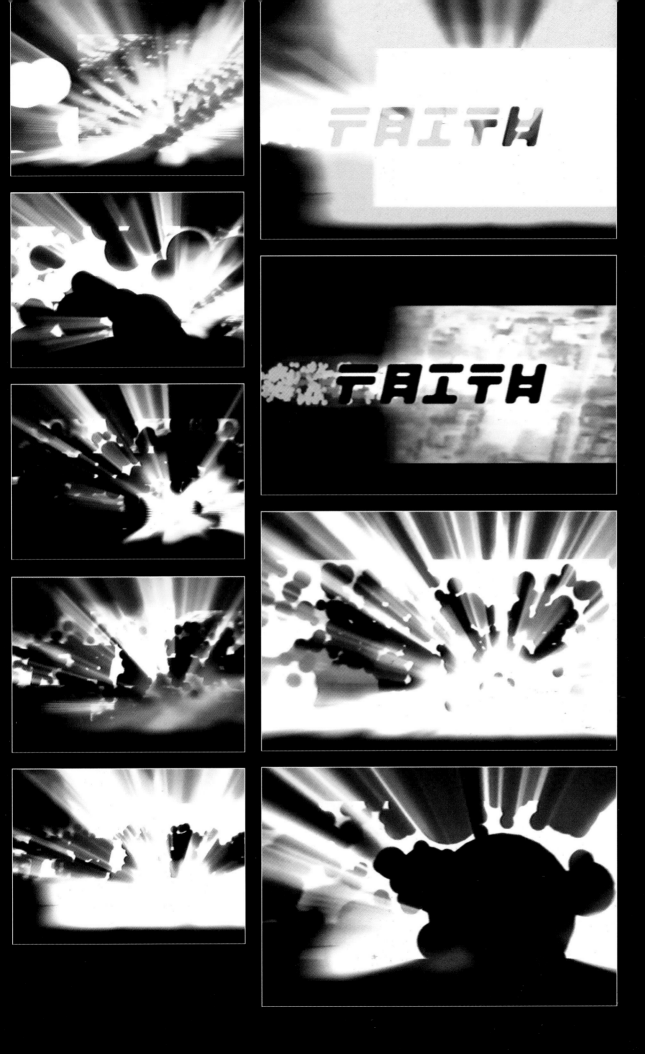

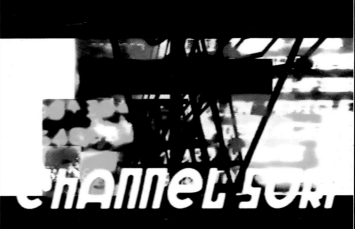

Professional Profiles

MONO*crafts

Studio Website
http://www.yugop.com

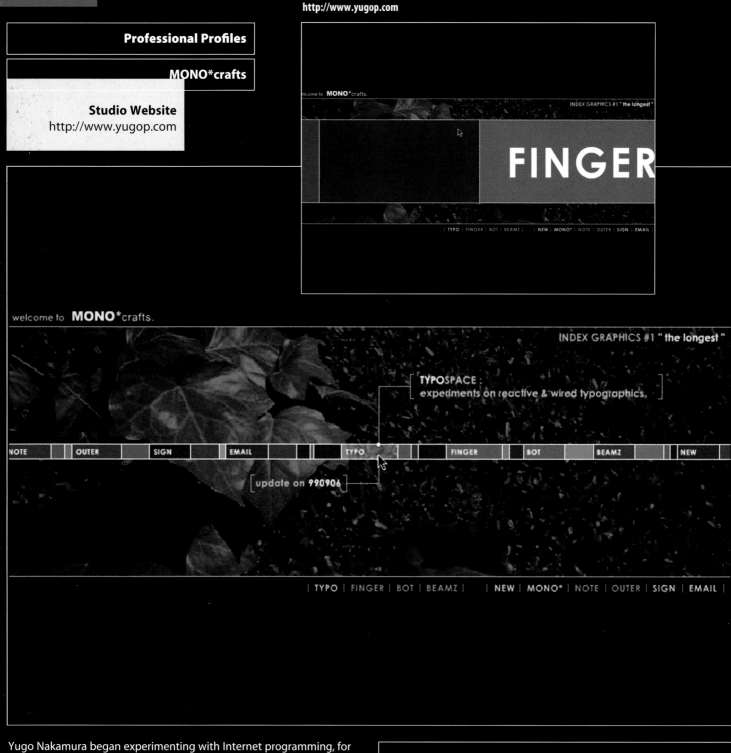

Yugo Nakamura began experimenting with Internet programming, for artistic ends, while at the University of Tokyo. Academically trained as an architect and structural engineer, Nakamura opened his independent studio, MONO*crafts, in 1996 to exert his interest in constructing innovative digital spaces and human-computer interfaces with computer code. Presented on these pages is the MONO*crafts website, which is the center of Nakamura's experiments.

Nakamura has adapted his architectural and engineering sensitivities to digital typography to create a new dimension for the website traveler to navigate and read type. Through complex coding, Nakamura literally gives the visitor to his website the power to bring typography to life. The interface technology is known as *reactive* in that the visual elements on screen react to the visitor's mouse movements and clicks. This is not the simple response that most digital environments provide, in which the active pointing and clicking of a specific word in a body of text leads the Internet traveler to yet another body of information. In Nakamura's website, the elements follow the mouse curser as it moves around the computer screen, waiting to re-act to the visitor's actions.

what's NEW? at mono*crafts.

MONO*crafts' site is always in progress.
Many projects in future are still in our mind...

991013
MONO*craft's new member "GOTA Nakamura" was born.
With his special technic of sudden pee, now he is seriously changing
our working environment. Please be patient for delayed schedules ...

INDEX GRAPHICS #2 " LINEAR-FLOW "

ct
1999 21:48:25
10/30

Nov

Dec

BACK TO TOP ●

TYPO SPACE

INDEX GRAPHICS #3 " Nervous matrix "

A SPACE FILLED WITH REACTIVE & WIRED TYPOGRAPHICS.

7	8	9
4	5	6
1	2	3

VOL1. PRIMARY STUDIES.
Just a tiny study on basic keyboard interaction.

● CLICK TO LAUNCH

BACK TO TOP ●

Presented on these pages are the MONO*crafts contents and timeline environments, respectively called *The Longest* and *Linear-Flow*. Both environments provide an ongoing documentation, in linear bands of information, of Nakamura's projects. The mouse movements cause these bands to slide to the left or the right, forward or backward, in the visitor's viewing frame. A click of the mouse over a particular area will bring the visitor to a new environment. Featured on the next five pages is the environment *Typospace,* which contains several experiments in human-computer typographic interfacing.

Volume 3, The Nervous Matrix, uses the *Mona Lisa* as its subject. Each of the nine numeric keys (zero not included) on the computer keyboard corresponds to a module in the nine-square matrix over the face of the Da Vinci masterpiece. When the traveler presses a key, the module, and the image information contained in that module, swells, shrinks, quivers, then snaps back to its original shape in response to the keyboard action. Repetitious pressing of the numeric keys result in a mischievous—yet rhythmic—distortion of the already ambiguously featured face of Mona Lisa that plays before the eyes of the visitor. Nakamura also uses his *Nervous Matrix* for the *Typospace* interface.

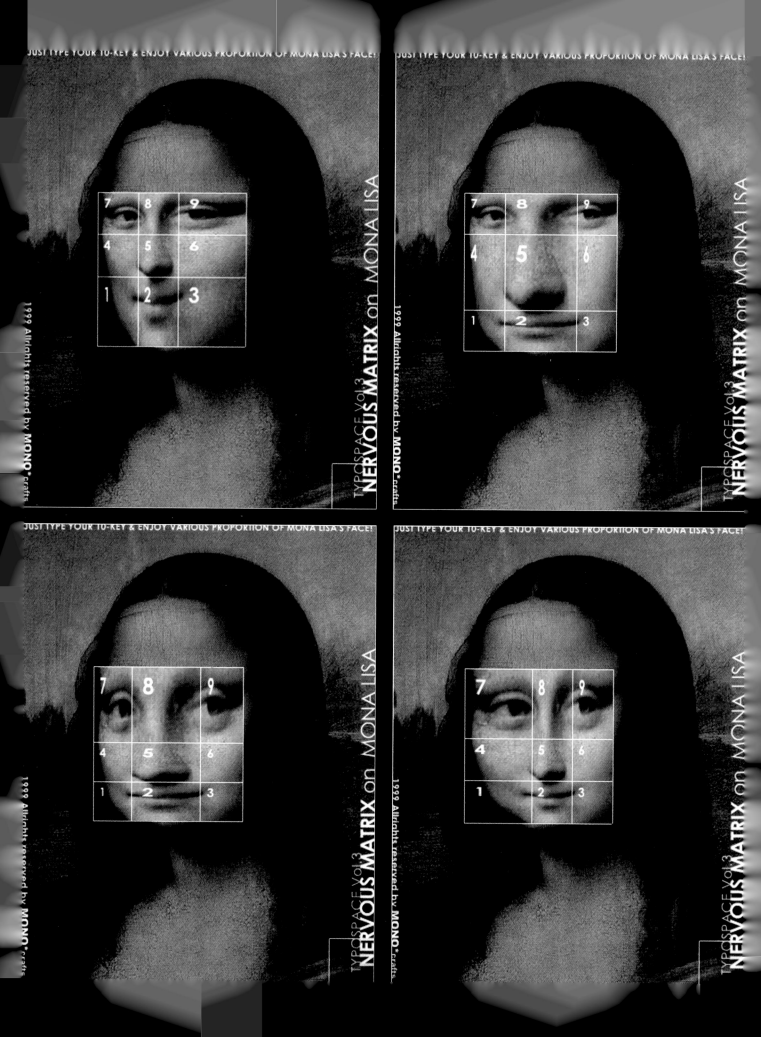

TYPOSPACE

vol.1 REACTIVE TYPO-WRITER.

1	2	3	4	5	6	7	8	9	0	-	^	\

Q W E R T Y U I O P @ [

A S D F G H J K L ; :]

Z X C V B N M SPACE B S

created by **MONO⁺**crafts.

'NOTE:This media doesn't work in "**CapsLock**" mode. Please unlock CapsLock key.

TYPOSPACE

vol.1 REACTIVE TYPO-WRITER.

created by **MONO⁺**crafts.

'NOTE:This media doesn't work in "**CapsLock**" mode. Please unlock CapsLock key.

In *Volume 2, Book of Typo-Beat,* Nakamura invites the visitor to sign his guest book. A visually elaborated keyboard is re-created on screen for this purpose. Here, the visitor may type and record a message for replay by other visitors. When replayed, the recorded message assembles as the letters spring from their homes on the keyboard, fly gracefully through space in various shades of translucent gray, and fall into linear marching order at the top of the screen. When the message is complete, a final pulse runs through the letterforms to announce its entrance.

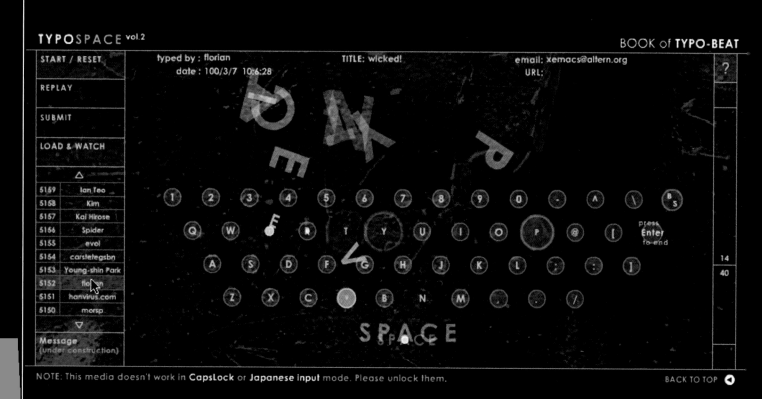

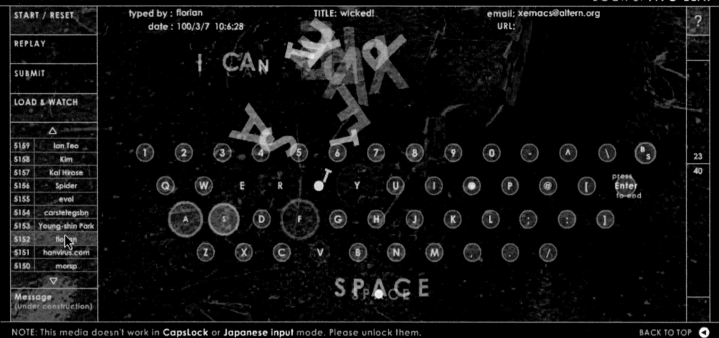

START / RESET

REPLAY

SUBMIT

LOAD & WATCH

△

5159 Ian Teo
5158 Kim
5157 Kai Hirose
5156 Spider
5155 evol
5154 carstetegsbn
5153 Young-shin Park
5152 florian
5151 hanvirus.com
5150 morsp

▽

Message
(under construction)

typed by : florian
date : 100/3/7 10:6:28

TITLE: wicked!

email: xemacs@altern.org
URL:

?

23
40

I CAN

SPACE

NOTE: This media doesn't work in **CapsLock** or **Japanese input** mode. Please unlock them.

BACK TO TOP ◀

TYPOSPACE vol.2

BOOK of **TYPO-BEAT**

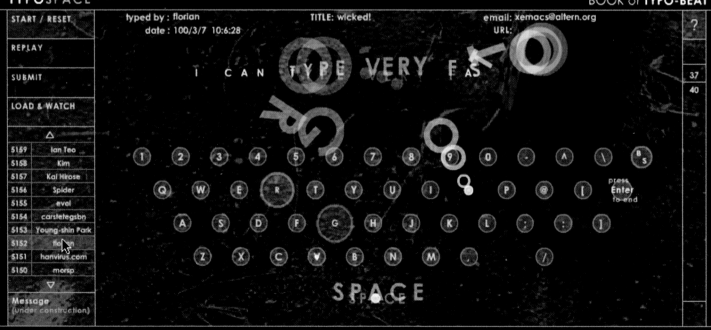

START / RESET

REPLAY

SUBMIT

LOAD & WATCH

△

5159 Ian Teo
5158 Kim
5157 Kai Hirose
5156 Spider
5155 evol
5154 carstetegsbn
5153 Young-shin Park
5152 florian
5151 hanvirus.com
5150 morsp

▽

Message
(under construction)

typed by : florian
date : 100/3/7 10:6:28

TITLE: wicked!

email: xemacs@altern.org
URL:

?

37
40

I CAN TYPE VERY FAST

SPACE

NOTE: This media doesn't work in **CapsLock** or **Japanese input** mode. Please unlock them.

BACK TO TOP ◀

159 | 116 · *Citizens Band* · PARAMOUNT PICTURES · 1977
Director: Jonathan Demme
Title Sequence Designer & Director: Pablo Ferro
2nd Unit Director for Title Sequence: Pablo Ferro
Music: Jack Nitzsche

160 | 117 · *Bullitt* · WARNER BROS. · 1968
Director: Peter Yates
Title Sequence Designer & Director: Pablo Ferro
2nd Unit Director for Title Sequence (first shot): Pablo Ferro
Music: Lalo Schifrin
Optical: The Optical House, NY

161 | 118 · *Burlington Mills* · BURLINGTON MILLS · 1964
Director: Pablo Ferro
Designer: Pablo Ferro
Music & Sound Effects: Pablo Ferro & Music for Film, NY

162 | 118 · *The Thomas Crown Affair* · UNITED ARTISTS / MIRISCH · 1968
Director: Norman Jewison
Title & Polo Sequence Designer & Director: Pablo Ferro
Muliple Screen Structure Creator & Editor: Pablo Ferro
Music: Michel Legrand
Optical: National Screen Service, LA

163 | 119 · *To Live and Die in LA* · MGM / UA · 1985
Director: William Friedkin
Title Sequence Designer & Director: Pablo Ferro
Music: Wang Chung
Calligraphic Pictures Producer: Allen Ferro

164 | 119 · *Married to the Mob* · ORION PICTURES · 1988
Director: Jonathan Demme
Title Sequence Designer & Director: Pablo Ferro
2nd Unit Director for Title Sequence: Pablo Ferro
Music: 'Mambo Italiano', sung by Rosemary Clooney
Calligraphic Pictures Producer: Allen Ferro

165 | 119 · *Men in Black* · SONY / COLUMBIA PICTURES · 1997
Director: Barry Sonnenfeld
Title Sequence Designer & Director: Pablo Ferro
Digital Background Imaging: Alan Munro
Music: Danny Elfman

166 | 120 · *Woman of Straw* · UNITED ARTISTS · 1964
Director: Basil Dearden
Title Sequence Creator, Designer & Director: Pablo Ferro
Music: Ludwig von Beethoven
Optical: National Screen Service, UK; Vincent Cafarelli

167 | 121 · *To Die For* · COLUMBIA PICTURES · 1995
Director: Gus Van Sant
Title Sequence Creator, Designer & Director: Pablo Ferro
Title Sequence Editor: Alan Ferro
Music: Danny Elfman
Optical: CRC

168 | 122 · *FMS Films* · FERRO, MOGUBGUB & SCHWARTZ · 1961
Director: Pablo Ferro, Fred Mogubgub
Designers: Jon Aron, Fred Mogubgub, Pablo Ferro, Trinkaus, Aron and Wayman
Music: Bob Prince

169 | 123 · *MYOB* · NBC · 2000
Series Creator: Don Roos
Title Sequence Creator, Designer & Director: Pablo Ferro
Hand Lettering: Harold Adler & Pablo Ferro
Music: Christopher Tyng
Digital Artists: Barbara Lee Gottlieb, Jason Cook, Adam Stern
Title Sequence Producer: Joy M. Moore

170 | 125 · *Behind the Scenes* · DISCOVERY INTERNATIONAL (Laura Frankel)
Creative/Design: M, Inc. (Joel Markus)
Sound: Sound Techniques
Film: Mark Moran
Post House: ViewPoint Studios
Flame: David DiNisco
Producer: David Shilale

171 | 127 · *Science/Travel ID* · DISCOVERY INTERNATIONAL (Laura Frankel)
Creative/Design: M, Inc. (Joel Markus)
Sound: Sound Techniques
Film: Heck Yes!
Post House: ViewPoint Studios
Flame: David DiNisco
Wavefront: David So
Producer: David Shilalle
Ilustrated storyboards: Leslie Bistrowitz

172 | 128 · *Nature ID* · DISCOVERY INTERNATIONAL (Laura Frankel)
Creative/Design: M, Inc. (Joel Markus)
Sound: Sound Techniques
Film: Mark Moran
Post House: ViewPoint Studios
Flame: David DiNisco
Producer: David Shilale

173 | 130 · *Savage Sun* · DISCOVERY INTERNATIONAL (Gaynelle Evans)
Creative/Design: M, Inc. (Joel Markus)
Logo Design: Jen Harrington (Discovery channel)
Editorial: Charley Tang

174, 175, 176 | 131 · ESPN INTERNATIONAL (Andy Bronstein, Jody Markley)
Network Identity Package
Creative/Design: M, Inc. (Joel Markus)
Post House: ViewPoint Studios
Flame: David DiNisco
Producer: David Shilale

177 | 132, 178 | 133 · *A Closer Look* · A&E · USA
Network Identity Package
Creative Director: Elaine Cantwell
Designer: Matthew Hall
Art Director: Joaquin Grey
Director of Photography: Patrick Loungway
Henry Artist: Scott Milne
Telecine: Dave Hussey
Producer: Eric Black
Executive Producer: John Sideropoulos

179 | 134 · *No Limits* · SHOWTIME NETWORKS · USA
Network Identity Package
Creative Director/Designer: Elaine Cantwell
Designer: Todd Neale
Director of Photography : Andrew Turman
Art Director: Keith Mitchell
Colorist: Dave Hussey
Henry Artist: John Eineigl, Tim Byrd
Editor: Jay Lizarraga
Producer: Patty Kiley
Executive Producer: John Sideropoulos

180 | 135 · *Danger Reel* · 13TH STREET · France
Network Identity Package
Creative Director/Designer: Matthew Hall
Animation: Matthew Hall
Editor : Mike Jones
Producer: Brett Battles
Executive Producer: John Sideropoulos

181 | 136 · *Reaction* · RTL · Germany
Network Promotional Package
Creative Director: Jeff Boortz
Designer: Scott Matz
After Effects Animators: Scott Matz/Camille Chu
Henry Artist: Scott Milne
Producer: Patty Kiley
Executive Producer: John Sideropoulos

182 | 137 · *The Evolution of Ideas* 3 Ring Circus for Promax & BDA 1998 · USA
Video presentation
Creative Director: Jeff Boortz/Elaine Cantwell/Curt Doty
Designer: Scott Matz
Illustrator: April Walker
Editor: Joseph Conarkov
Producer: Patty Kiley

183 | 138 · *Sign of the Times* · TARGET · USA
Commercial: network television on-air campaign
Director: Elaine Cantwell
Creative Director: Dave Peterson
Art Director: Joaquin Grey
Director of Photography : Andrew Turman
Visual Effects: Jake Parker
Producer: Patty Kiley/Tommy Murov
Executive Producer: John Sideropoulos

184 | 139 · *Modern World* · SONY ENTERTAINMENT TELEVISION · Taiwan, Latin America, India · Network Identity Package
Creative Director/Designer: Jim Kealy
Director of Photography: Patrick Loungway
Art Director: Jodi Ginnever
Editor: Matt Liam
Henry Artist: Jim Kealy
Producer: Patty Kiley
Executive Producer: John Sideropoulos

185 | 139 · *Uno* · TELEUNO
Network identity package
Creative Director: Jeff Boortz
Designer: Nick DiNapoli
Type Animation: Nick DiNapoli
Henry Artist: John Eineigl
Producer: Eric Black
Executive Producer: John Sideropoulos

Bibliography

Books

Bellantoni, Jeff, and Woolman, Matt, *Type in Motion: Innovations in Digital Graphics,* London, Thames and Hudson, 1999

Bringhurst, Robert, *The Elements of Typographic Style, second edition,* Vancouver, BC, Hartley & Marks, 1992

Bruggen, Coosje van, *John Baldessari,* New York, Rizzoli International, 1990.

Burger, Jeff, *The Desktop Multimedia Bible,* Reading, Massachusetts, Addison-Wesley Publishing Company, 1993

Carter, Rob, *Working with Computer Type 4, Experimental Typography,* Crans, Switzerland, RotoVision SA, 1997

Carter, Rob, *Working with Computer Type 3: Color and Type,* Crans, Switzerland: RotoVision SA, 1997

Cotton, Bob, and Oliver, Richard, *Understanding Hypermedia,* London, Phaidon Press, 1993

Day, Ben; Carter, Rob, and Meggs, Philip, *Typographic Design: Form and Communication, second edition,* New York, John Wiley and Sons, 1993

Drew, John T. and Drew, Ned, eds, *Design Education in Progress: Process and Methodology,* volume 1, Richmond, Center for Design Studies, Virginia Commonwealth University, 1998

Eisenstein, Sergei, *Film Form,* San Diego, California, Harcourt Brace Jovanovich, 1949

Eisenstein, Sergei, *Film Sense.* San Diego, California: Harcourt Brace Jovanovich, 1949

Giannetti, Louis, *Understanding Movies, seventh edition,* Upper Saddle River, New Jersey, Prentice Hall, 1972

Gotz, Veruschka, *Color & Type for the Screen,* Crans, Switzerland, RotoVision SA in collaboration with Grey Press, 1998

Gross, John, *The Oxford Book of Aphorisms,* Oxford, Oxford University Press, 1983

Halas, John, *Film & TV Graphics: An International Survey of Film and Television Graphics,* Zurich, W. Herdeg, Graphis Press, 1967

Herdeg, Walter, ed, *Film & TV Graphics 2: An International Survey of the Art of Film Animation,* Zurich, Graphis Press, 1976

Hiebert, Kenneth J., *Graphic Design Process: Universal to Unique,* New York, Van Nostrand Reinhold, 1992,

Kandinsky, Wassily, *Point and Line to Plane,* New York, Dover Publications, 1979

Katz, Steven D., *Film Directing Shot by Shot: Visualizing from Concept to Screen,* Studio City, California, Michael Wiese Productions, 1991

Kunz, Willi, *Typography, Macro- and Microaesthetics,* Sulgen, Switzerland, Verlag Niggli AG, 1998

Landow, George P., *Hyper/Text/Theory.* Baltimore, Maryland, The John Hopkins University Press, 1994

Laybourne, Kit, *The Animation Book,* New York, Three Rivers Press, 1998

McCloud, Scott, *Understanding Comics: The Invisible Art,* New York, HarperPerennial and Kitchen Sink Press, 1993

McCluhan, Marshall, *Understanding Media: The Extensions of Man,* Cambridge, Massachusetts, MIT Press, 1994

McLean, Ruari, *The Thames and Hudson Manual of Typography,* London, Thames and Hudson, 1980

Mamet, David, *On Directing Film,* New York, Penguin Books, 1991

Merritt, Douglas, *Graphic Design in Television,* Oxford, Focal Press, 1993

Miller, J. Abbott, *Dimensional Typography: Case Studies on the Shape of Letters in Virtual Environments,* Kiosk, distributed by Princeton Architectural Press, 1996

Mitchell, William J., *The Reconfigured Eye: Visual Truth in the Post-Photographic Era,* Cambridge, Massachusetts, MIT Press, 1992

Moholy-Nagy, Laszlo, *Vision in Motion,* Chicago, Paul Theobald and Company, 1965

Monaco, James, *How to Read a Film: The Art, Technology, Language, History, and Theory of Film and Media, Revised Edition,* New York, Oxford University Press, 1977

Muybridge, Edward, *The Human Figure in Motion,* New York, Dover Publications, 1955

Neuenschwander, Brody, *Letterwork: Creative Letterforms in Graphic Design,* London, Phaidon Press, 1993

Papanek, Victor, *Design for the Real World: Human Ecology and Social Change,* second edition, Chicago, Academy Chicago Publishers, 1984

Richard, Valliere T., *Norman McClaren, Manipulator of Movement. The National Film Board Years,* An Ontario Film Institute Book, Newark, University of Delaware Press, 1982

Small, David L., *Rethinking the Book,* Ph.D. Thesis, MIT, 1999

Spiekerman, Erik, and Ginger E.M., *Stop Stealing Sheep & Find out how Type Works,* Mountain View, California, Adobe Press, 1993

Tschichold, Jan, *The New Typography,* trans. Ruari McLean, Berkeley: University of California Press, 1995

Von Arx, Peter, *Film Design: Explaining, Designing with and Applying the Elementary Phenomena and Dimensions of Film in Design Education at the AGS Basel, Graduate School of Design,* New York, Van Nostrand Reinhold, 1983

Woolman, Matthew, *A Type Detective Story, Episode One: The Crime Scene,* Crans, Switzerland, RotoVision SA, 1997

Wong, Wucius, *Principles of Form and Design,* New York, John Wiley and Sons, 1993

Zettl, Herbert, *Sight, Sound and Motion: Applied Media Aesthetics,* Belmont, CA, Wadsworth Publishing Company, 1973

Articles

Bellantoni, Jeff, 'Typography in Motion,' *Design Education in Progress: Process and Methodology,* volume 1, pp. 98–109

Johnson, Polly, 'Typographic Process: From Stasis to Motion,' *Design Education in Progress: Process and Methodology,* volume 1, pp. 90–97

Ishizaki, Suguru, 'On Kinetic Typography,' *Statements,* volume 12, number 1, pp. 7–9

Owen, William, 'Design in the Age of Digital Reproduction,' *Eye,* number 14, volume 4

Worthington, Michael, 'Entranced by Motion, Seduced by Stillness . . . Type Today,' *Eye,* number 33, volume 9

Design Educators

Henk van Assen (Hattem, The Netherlands) graduated from the Royal Academy of Fine Arts, Department of Graphic Design and Typography, in The Hague, The Netherlands. He received his MFA in 1993 from Yale University, and has worked on projects ranging from book design to visual identities to signage systems. Clients have included: HarperCollins, Abrams, Hyperion, New York University, FGI Inc., the Dutch Institute for Industrial Design, ICC, the University of Texas at Austin, the Blanton Museum of Art, and the Performing Arts Center at the University of Texas. He currently works as a design consultant in New York City and teaches full-time in the School of Art at Yale University. He has also taught at the University of Texas at Austin, the School of Visual Arts in New York and The University of the Arts in Philadelphia, Pennsylvania. Henk was awarded one of the 1999 AIGA 50 Best Books, the 1999 Mitchell A. Wilder Award, and the 1998 Case Council for Advancement and Support of Education Award. In 2000, he was a juror for the AAUP 2000 Book, Jacket, and Journal Show.

Bob Aufuldish is a partner in *Aufuldish & Warinner* and an Affiliate Associate Professor at the California College of Arts and Crafts. He teaches graphic design, typography, and new media, and is the Design Director for Sputnik CCAC, a student-staffed design office producing work for the College. Bob has designed projects ranging from book design to poster design, to multimedia for such clients as Chronicle Books, Emigre Graphics, and Warner Brothers Records. He has participated in a number of exhibitions, including *Icons: Magnets of Meaning*, at the San Francisco Museum of Modern Art; *Designing/Living Within Limits,* sponsored by AIGA San Francisco; and *Can U Dig It?* at Postmasters Gallery in New York City. He launched *FontBoy* (www.fontboy.com), a digital type foundry, in 1995 to manufacture and distribute fonts designed by himself and others. Bob designed, photographed, and produced two limited-edition books about San Francisco: *600 Extra Hours* and *Dogs and Suds.* He is a typographic and photographic contributor to *Speak* magazine. Bob received both his BFA and MFA from Kent State University in Ohio.

Geoff Kaplan is the principle of General Working Group, a graphic design studio in Los Angeles, California. He received his MFA from Cranbrook Academy of Art and his BFA from Carnegie Mellon University. He has produced projects for Oliver Stone, Cranbrook Academy of Art, MOCA, Fox television, Channel One, The Walker Arts Center, California College of Arts and Crafts, and *Bordertown*—an award winning book project for Chronicle Books. He currently teaches at both California Institute of the Arts and Art Center College of Design. He has received awards from the American Center for Design, AIGA, The Type Directors Club, and *I.D.* magazine's design annual. A selection of his work was recently selected for San Francisco Museum of Modern Art's permanent design collection.

David Karam is the Director of the Design and Media department and Assistant Chair of Graphic Design at the California College of Arts and Crafts. He studied music and computer science at the University of Texas at Austin. In 1993 he formed *Post Tool Design* with Gigi Obrecht, a partnership specializing in multimedia. *Post Tool Design* has worked with America Online, Apple Computers, Autodesk, Body Shop International, Chiat Day, Chronicle Books, Colossal Pictures, *Dwell* magazine, Frogdesign, The Getty Institute, Marks and Spencer, Organic Online, Joan Quigley, Sony Pictures Entertainment, Steelcase Seating, Swatch Watch, AIGA San Francisco, Sony, VH1, and Warner Records. *Post Tool Design* is in the collection of the San Francisco Museum of Modern Art and the Cooper-Hewitt National Design Museum, Smithsonian Institute. Awards include *I.D.* magazine's Design Distinction in 1994 and Silver award in 1999, and e-phos International Festival of Film and New Media's best CD-ROM. *Post Tool* has twice been nominated for the Chrysler Innovation in Design award (1995 and 1997), and the Fleishhacker Foundation Grant for Artistic Achievement (1996).

Kendra Lambert is an instructor in Graphic and Interactive Communication at Ringling School of Art and Design in Sarasota, Florida. As a designer and educator, she is currently developing multimedia and interactive aspects of the curriculum at Ringling, and pursuing a personal interest in the language of signs. Kendra received her MFA from Virginia Commonwealth University.

Sonya Mead is a Senior Designer at Sapient Corporation, specializing in user-centered design for large scale websites. She also teaches several classes at the Art Institute of Boston, including Typography in Motion and Design for Interactive Media. Her work has been published in several publications including *Print*, *I.D.* magazine and *Business Week*. She received her MFA from Virginia Commonwealth University.

Cary Murnion and **Jonathan Milott** teach at Parsons School of Design in New York City. Along with their partner Stella Bugbee, they started *Agenda,* a design firm in New York City. All three partners met at Parsons School of Design, and have been working together ever since. *Agenda's* clients include Museum of Modern Art, Andrea Rosen Gallery, Astralwerks, The New Press, and MTV. *Agenda* was recently featured in the New Visual Artists Review 2000 issue of *Print* magazine. Inquiries may be directed to www.stateofagenda.com.

Professional Contributors

3 Ring Circus

1857 Taft Avenue
Hollywood, California
90028, USA
t: 323 957 3800 f: 323 469 4744
www.ooocircus.com

DePablo Productions

738 North Cahuenga Boulevard
Hollywood, California
90038, USA
t: 323 871 2936
f: 323 871 2943

Faith

26 Ann Street
Mississauga, Ontario
Canada L5G 3G1
t: 905 891 7410
f: 905 891 8937
faith@faith.ca

M: Design + Direction, Inc.

Nine Pickering Way
Salem, Massachusetts
01970, USA
t/f: 978 741 7684
mdesign@mediaone.net

MONO*crafts

302 MM-Building
2–8–9 Miyazaki
Miyamae-ku
Kawasaki, Kanagawa
Japan
t: 81 44 862 0091
yugo@yugop.com
www.yugop.com

Universities and Art Schools

The Art Institute of Boston at Lesley College

700 Beacon Street
Boston, Massachusetts
02215, USA
www.AIBoston.edu

California College of Arts and Crafts

5212 Broadway Street at College Avenue
Oakland, California
94618, USA
www.CCAC–ART.EDU

California Institute of the Arts (CalArts)

24700 McBean Parkway
Valencia, California
91355, USA
www.calarts.edu

University of Connecticut

School of Fine Arts
Department of Art and Art History
875 Coventry Rd, U–99
Storrs, Connecticut
06269, USA
www.art.uconn.edu

Parsons School of Design

New School University
66 Fifth Avenue
New York, New York
10011, USA
www.parsons.edu

Ringling School of Art and Design

2700 North Tamiami Trail
Sarasota, Florida
34234, USA
www.rsad.edu

University of Texas at Austin

Department of Art and Art History
Austin, Texas
78712, USA
www.utexas.edu

Other Contributors

Kim Westad designed and produced the flipbook that appears in the lower left corner of the even pages of the book—the old-fashioned way—by hand. Kim received her BFA from the University of Connecticut and is currently a designer with Quench Design in Providence, Rhode Island.
Inquiries: kwestad@yahoo.com

The excerpt from the song *Face on a Mountain*, used in sequence 084|056, is by **Benjamin Woolman** from his 1995 recording *Lost in Density,* ©1995 Benjamin Woolman, member (BMI). Benjamin received his BFA with honors in guitar performance (American finger-style) from the University of Wisconsin-Milwaukee/Wisconsin Conservatory of Music Cooperative Guitar Program. His second recording, *Stratovox,* was released in 1997. He can be heard on the recently released compilation recording *American Finger Style Guitar Circa 1999.*
Inquiries: www.users.uswest.net/~bwoolman/ or email beejd@aol.com

Acknowledgements

We would like to thank many people in the making of this book, without whom it would not have been possible:

The Qatar Foundation, School of the Arts, Virginia Commonwealth University, for generous grant support.

The Center for Design Studies, Department of Communication Arts and Design at Virginia Commonwealth University, and the Department of Art and Art History, School of Fine Arts at the University of Connecticut, for their support in this endeavor.

The contributing educators and designers: Bob Aufuldish, David Karam, Franceca Bautista, Dain Blodorn, Jason Botta, Ragina Johnson, Jereon Mimran, Makiko Tasumi, Oanh Troung, and Kim West; Kendra Lambert and Brian Mah; Geoff Kaplan, Adrianna Day, Sophie Dobrigkeit, and John Kieselhorst; Sonya Mead, Abraham Blanco, Aaron Carmisciano, and Rie Takeuchi; Daniel Ben-Kiki, Michele Granville, Carla Imperati, Kate Kenny, Christian Kubek, Aaron Lazauski, Lisa Milazzo, Georgina Montana, Carissa Rutkauskas, and Phuanh Tran; Jonathan Milott, Cary Murnion, Marc Cassata, Andrea Dionisio, Hanna Han, Mike Helmle, Yu-Jin Lee, Agustin Llona, Kathleen McGowan, and Rei Yoshimoto; Hendrikus Van Assen, Tanya Chi, Kevin Conner, Brooke Howsley, Lauren Saunders, Elaine Shen, and Kelly Stevens; Joel Marcus; Lori Pate, Susan Scarlet, and DeeDee Li of 3 Ring Circus; Yugo Nakamura; Pablo Ferro; and Paul Sych.

At Virginia Commonwealth University: John DeMao, Anne Graves, Dr Richard Toscan, Bob Kaputof, Jerry Bates, and the Graphics Lab staff.

Ben Woolman, for his musical contribution, and for the many hours of enjoyment we have received from his music.

Kim Westad, for her incredible patience, and for making the wonderful flipbook.

Jonathan Mehring and Angeline Robertson for the photography on pps. 16-17, 70-71, & 114-115.

Ned Drew, for allowing us to use his artwork of the—uhh, philoscope—no, photoscope—no, tamascope—no, tomascope—no, thaumatrope (whatever!)—on page 42.

Siera Westad-Godbout for her photo debut.

Rupert and Caulder who are jealous of Patches.

Our wives and families for their ongoing support.

Our patient and understanding editor at RotoVision, Kate Noël-Paton.

In the battle between the old and the new, it is not a question of creating a new style for its own sake. But new needs and new contents create new forms which look utterly unlike the old. And it is just as impossible to argue away these new needs as it is to deny the need for a truly contemporary style of typography.

That is why [designers] today have a duty to concern themselves with these questions. Some have forged ahead with energy and creative success: for the rest, however, it seems that there is still almost

everything

to do.

Jan Tschichold, *The New Typography*